Compiled by Mary Rose Storey
Introduction by David Bourdon

MONA LISAS

Harry N. Abrams, Inc., Publishers, New York

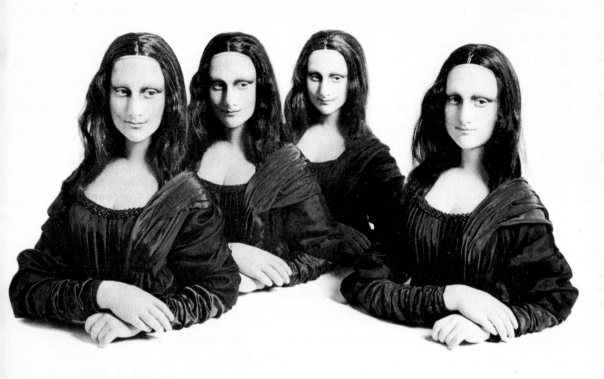

Library of Congress Cataloging in Publication Data

Storey, Mary Rose.
 Mona Lisas.

 Includes index.
 1. Leonardo da Vinci, 1452-1519—Influence.
2. Leonardo da Vinci, 1452-1519. Mona Lisa. I. Bourdon,
David. II. Title.
ND623.L5S755 759.5 79-11434
ISBN 0-8109-2194-4

Library of Congress Catalog Card Number: 79-11434

Published in 1980 by Harry N. Abrams, Incorporated, New York

Printed and bound in Japan

MONA LISAS

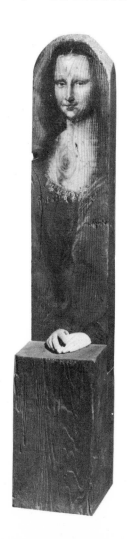

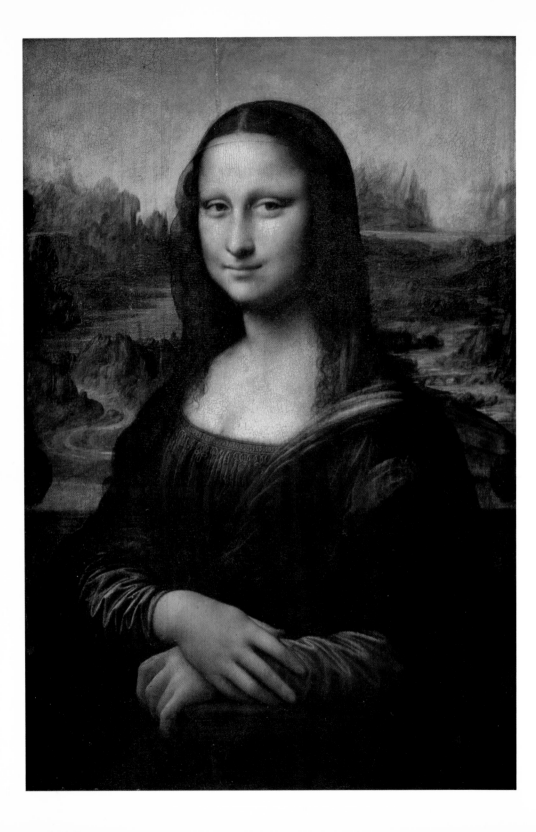

ne of the most celebrated ladies in history, she has captivated an adoring public for close to five centuries. She is among the most renowned women of the world, ranking with Sappho, Cleopatra, Joan of Arc, Pocahontas, Elizabeth I, Marie Antoinette, Catherine the Great, and Victoria. In Paris, where this Italian lady resides, she receives more visitors than any other personage in the city. People pilgrimage from all over the world to gaze at her as she sits serenely on a wooden chair. On her rare travels, she is treated as a visiting head of state, provided with first-class accommodations and a retinue of escorts and security guards. She is, of course, the *Mona Lisa*.

Men from all classes of society—from kings to carpenters—have been infatuated with the *Mona Lisa*. Francis I, king of France, installed her among stucco nymphs in his luxurious bathing quarters in the château at Fontainebleau. Napoleon Bonaparte, who treasured her as "the Sphinx of the Occident," kept her in his bedroom in his palace at the Tuileries. The Marquis de Sade, who mercifully never got his hands on her, considered her to be "the very essence of femininity" and was excited by her "devoted tenderness." An Italian laborer with a police record did manage to get his hands on her, forcibly removing her from the Louvre and carrying her off to his shabby quarters in a Paris rooming house, where he held her captive for two years. Few heroines in novels or drama can match the *Mona Lisa*'s glamorous, adventure-filled experiences.

While the *Mona Lisa* is revered as Leonardo da Vinci's most beautiful painting, a Renaissance masterpiece and one of the great artworks of all time, its fame derives in good measure from hundreds of copies, some dating from the sixteenth and seventeenth centuries,

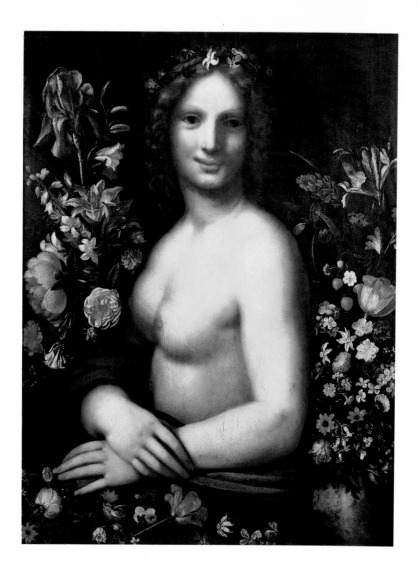

Anonymous. *Nude Gioconda*. 17th century. Oil, 30¾ x 23⅝". Accademia Carrara, Bergamo

and thousands of reproductions. The *Mona Lisa*'s face and name have been commercially exploited in virtually every part of the world. Beauty parlors, hair pins, and wigs are named after her. Hotels, restaurants, and canned tomatoes assume a touch of class when they are called "Mona Lisa." People name their female cats and dogs "Mona Lisa"—or, if they have two female pets, "Mona" and "Lisa." The name is also popular among prostitutes and strippers, because it implies high quality and customers find it easy to remember. Even children

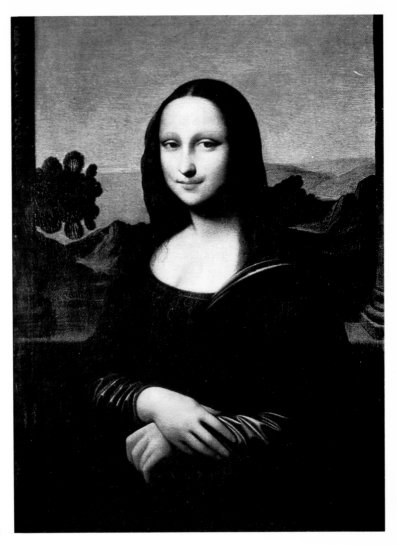

Mona Lisa copy (claimed to be the original). 16th century. Oil, 33¾ x 25⅞″. Collection Pulitzer, London

are not immune to the painting's fame, since the *Mona Lisa* has figured in "Li'l Abner," "Mandrake the Magician," and other comic strips. Poets and songwriters have contributed quantities of cadenced praise, but none more stylishly than Cole Porter in his 1934 classic "You're the Top," in which he positioned the *Mona Lisa* among such pinnacles of civilization as Mahatma Gandhi, Mickey Mouse, and Camembert cheese.

Armies of scholars have sleuthed through ancient manuscripts in remote libraries to glean what they can

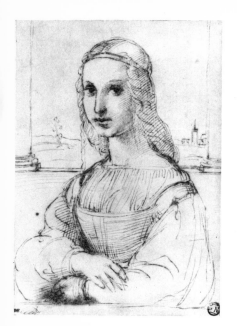

Raphael. *Florentine Portrait*. c. 1504. Ink, 8¾ x 6¼". The Louvre, Paris. (Photograph Musées Nationaux)

about the *Mona Lisa*, because its early history is so obscure or disputable. The picture, which is painted on a 30-by-21-inch poplar panel, is unsigned and undated. There are no records of the painting having been commissioned. There is no reference to the work in Leonardo's extensive notebooks and there are no known preliminary studies for it. Most scholars agree that it is one of Leonardo's later works, begun when he was more than fifty years old. Born in 1452, Leonardo painted the *Mona Lisa* toward the end of a career during which he had already produced the portrait of Ginevra de' Benci, the *Virgin of the Rocks*, the *Lady with an Ermine*, and the *Last Supper*. Some historians believe Leonardo began painting the *Mona Lisa* in Florence in 1503 or 1504 and that he completed it between 1506 and 1510. Other experts believe the painting was executed in Rome between 1513 and 1516. In arguing for the earlier dates, scholars cite Giorgio Vasari's biography of Leonardo, as well as a Raphael drawing, possibly made in 1504, that seems clearly inspired by the *Mona Lisa*. In arguing for the second dates, scholars point out that the portrait conforms stylistically with Leonardo's later works.

If Leonardo painted the *Mona Lisa* in Florence, where he resided between 1503 and 1507, he presumably took the painting with him when he moved to Rome, where he worked between 1513 and 1516 under the patronage of Giuliano de' Medici, the youngest son of Lorenzo the Magnificent and the brother of Pope Leo X. About the time that Giuliano ceased to be Leonardo's patron, King Francis I of France invited Leonardo to come and live as his guest at the royal residence in Amboise, in the Loire Valley about 100 miles southwest of Paris. In 1516 or 1517 Leonardo journeyed to France, accompanied by at least one pupil and servant, and baggage containing the *Mona Lisa*. Francis provided Leonardo with an annuity of 700 gold crowns, as well as a handsome brick manor house, connected to the château at Amboise by an underground tunnel. Leonardo was given the title of *"Premier peinctre et ingenieur et architecte du Roy,"* but was given no specific duties. He earned his keep by conversing (brilliantly, one assumes) with the king, who visited Leonardo almost daily, calling him *"mon père."* Leonardo made few or no paintings while in France, so Francis somehow managed to obtain many of the great works Leonardo had brought from Italy, including the *Virgin of the Rocks*, the *Virgin and Child with*

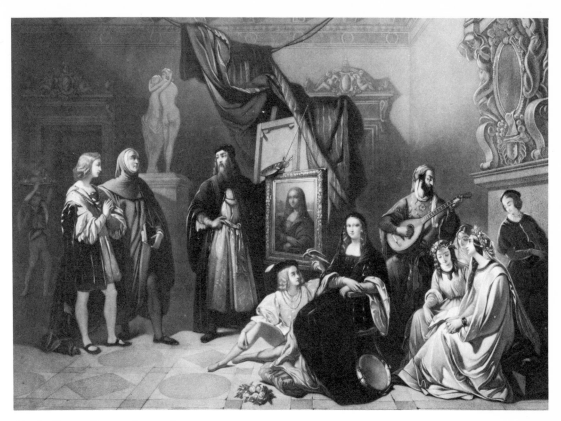

Aimée Brune-Pages. *Leonardo Painting the Mona Lisa*. 1845. Engraved by Charles Lemoine from the oil original, 16½ x 23⅝". Bibliothèque Nationale, Paris

St. Anne, and *St. John the Baptist.* After Leonardo's death in 1519, according to legend, Francis bought the *Mona Lisa* for 4,000 gold florins from Leonardo's pupil and principal heir, Francesco Melzi. Identified in early records as a "courtesan in a gauze veil," the *Mona Lisa* eventually wound up, along with other paintings, in the royal baths in the château at Fontainebleau.

Tradition has it that the painting portrays Lisa de' Gherardini, a Florentine woman born in 1479, who at age sixteen became the third wife of Francesco del Giocondo, a Florentine silk merchant and civic leader. For this reason the painting is known in Italy as *La Gioconda* and in France as *La Joconde.* In English-speaking countries, the painting is known as the *Mona Lisa.* But the "Mona" is misleading, since it derives from *madonna* and its diminutive *monna,* which are comparable to Madam or Mistress. In northern Italy it would be improper to address a woman as Mona, since

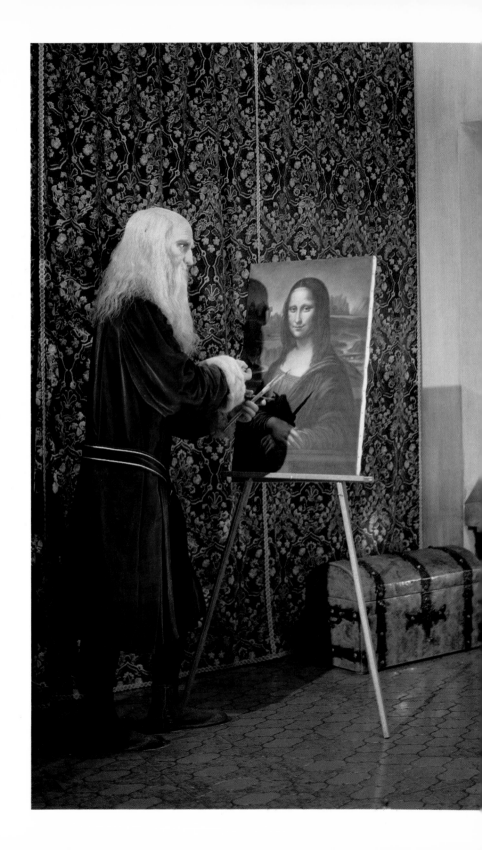

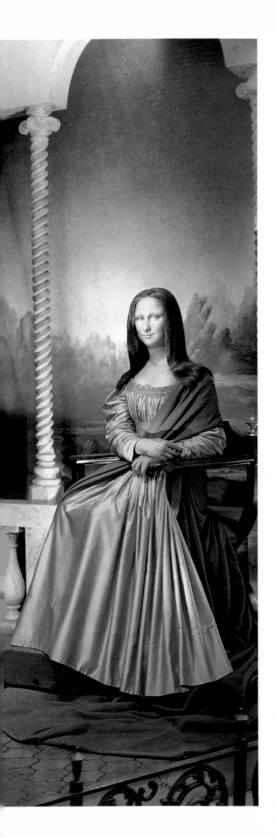

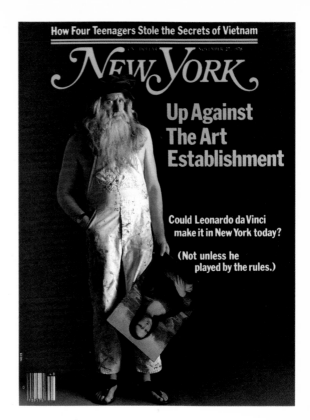

Ken Ambrose. *Up Against the Art Establishment*. November 27, 1978. Cover, *New York* Magazine, New York

Mona Lisa Posing for the Master. Waxwork figures, Movieland Wax Museum, Buena Park

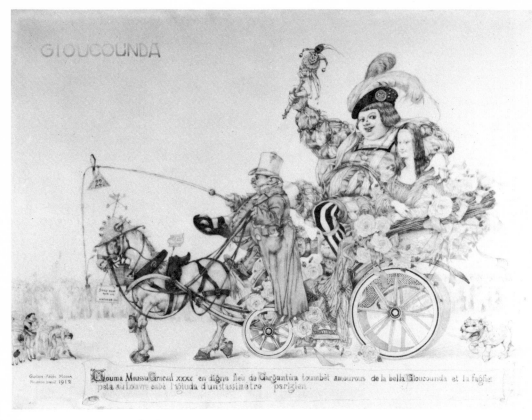

GIOUCOUNDA

G. A. Mossa. *King Carnival
with Mona Lisa*. 1912. Ink, 28⅜
x 39⅜". Musée Cheret, Nice

there it is a slang word for female genitalia.

Hardly anything is known about Lisa del Gio-
condo. But then it is not even known whether the paint-
ing is a portrait of a specific individual or, instead, an
idealized, even allegorical image based only in part on an
actual physiognomy. The possibility exists that the
painting began as a portrait and that Leonardo later
changed his intention, turning it into an allegorical fig-
ure. While the identity of the sitter remains a matter of
interest, it is Leonardo's interpretation that fascinates,
not the model herself. The *Mona Lisa* has a universality
that completely overshadows the individuality of its
model or models. Wanting to know the sitter's identity
seems ultimately irrelevant, like wanting to know the
names of the actual women who may have inspired such
archetypal fictional characters as Emma Bovary, Anna
Karenina, and Scarlett O'Hara.

In 1517, in Amboise, Leonardo received a visit from Cardinal Louis of Aragon, whose secretary, Antonio de' Beatis, noted that they were shown a portrait of "a certain Florentine lady," commissioned by Giuliano de' Medici. This information suggests that Leonardo may have produced the painting in Rome while under the patronage of Giuliano. But there is no corroborating evidence that Giuliano, in fact, did commission a portrait. Moreover, it is not even certain that the painting the cardinal and his secretary were shown was the one we know as the *Mona Lisa*.

Vasari is the first writer to identify the sitter as Lisa del Giocondo—but in 1550, thirty-one years after Leonardo's death. Vasari, in his *Lives of the Painters, Sculptors and Architects*, wrote: "For Francesco del Giocondo Leonardo undertook to execute the portrait of his wife, Mona Lisa. He worked on this painting for four years, and then left it still unfinished; and today it is in the collection of King Francis of France, at Fontainebleau." Vasari gathered some of his information from the *Anonimo Gaddiano*, a book by an unknown Florentine writer, whose manuscript probably was written in the late 1530s. The *Anonimo* asserts that Leonardo painted a portrait of Francesco del Giocondo, making no mention of his wife. Did Vasari make or correct a mistake while picking up facts from the *Anonimo*? Also, if the *Anonimo* is correct, why is there no other evidence of any portrait of Francesco by Leonardo?

Vasari never knew Leonardo and never laid eyes on the *Mona Lisa*. But in 1566 Vasari did visit Francesco Melzi, Leonardo's heir, in Milan. Melzi had been Leonardo's apprentice since about 1507 and certainly should have known the identity of the sitter. Melzi had the opportunity to clarify the facts before Vasari published his revised and enlarged edition of the *Lives* in 1568. Also, members of the Giocondo and Gherardini families probably were still active in Florence between 1550 and 1568 and they, too, would have had the opportunity to correct Vasari.

But if Vasari is right and the painting really is a portrait of Lisa del Giocondo, it is curiously lacking in contemporary detail. The dress is unusually plain for a gentlewoman and does not seem to conform with current fashion. The hair is not artfully styled but, instead, simply parted in the middle and hanging down in tightly

coiled curls. And there is not a single piece of jewelry which could denote wealth or social position. Only the crossed hands seem to signify upperclass politesse.

The pose of the *Mona Lisa* was considered innovative in Leonardo's time and was widely imitated. It is a refined variation upon the classical *contrapposto*, an Italian word often applied to a pose in which one part of a body twists in a different direction from the rest. The woman is seated in a wooden chair that faces toward the spectator's left. Her left arm rests on the arm of the chair, which is almost parallel to the picture plane. Her right hand extends across her torso to gently clasp her left hand. Her torso is turned to the left and her head is turned even farther to provide a three-quarter view of the face. Additionally, her eyes turn still farther to confront the spectator directly. The subtle positionings of the shoulders, head, and eyes, each on a different axis, result in a figure that seems to have a living presence. The turning pose also accentuates the expression of the warily amused eyes, which appear to follow the viewer.

Another quality that greatly impressed Leonardo's contemporaries was his masterful use of *sfumato*, an Italian word used to describe the smoky, almost imperceptible shading from light to dark in order to create soft contours and the illusion of relief. The *sfumato* was attained through the application of many glazes, all of them so thin and fluid that not a single brush stroke can be found anywhere in the work. The *sfumato* renders indistinct the corners of the eyes and the lips, heightening the mysterious, ambiguous expression. Leonardo's skillful use of *contrapposto* and *sfumato* were so influential that, by the end of the sixteenth century, there were scores of lesser artists who painted freakishly contorted figures, often plunged in impenetrable gloom.

In contrast to the lifelike depiction of the woman, the fantastic landscape in the background is obviously invented. It is a barren, desolate environment of jagged rocks, spiky mountains, and winding rivers. The presence of a road and bridge hints that human activities once took place in this awesome terrain, but were terminated at some point. The imaginary landscape is not unique to the *Mona Lisa;* Leonardo employed a similar setting for his *Virgin of the Rocks.* How inconvenient for art historians that Leonardo refrained from painting a background that is recognizably Florence, Milan, or Rome!

opposite:
Mona Lisa copy (claimed to be the original). 16th century. Oil. Collection Lord Brownlow of Grantham, Belton House, Lincolnshire

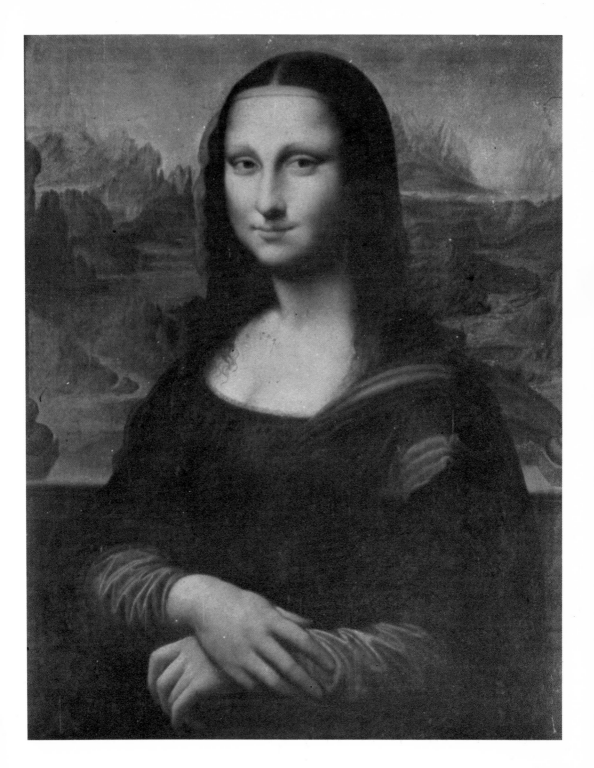

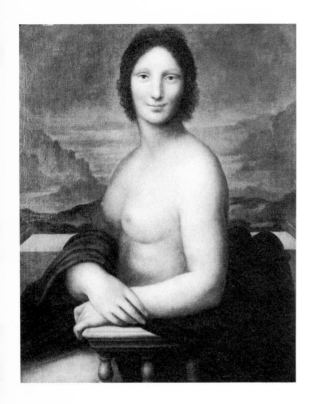 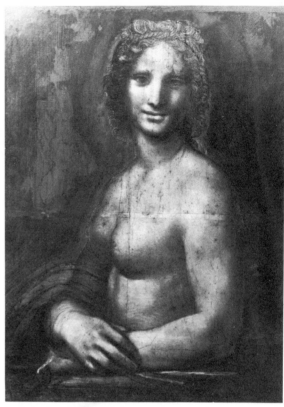

above left:
Anonymous. *La Belle Gabrielle*.
16th century. Oil, 35 x 25″.
Collection Lord Spencer,
Althorp, Northampton.
(Photograph Beedle & Cooper)

above right:
Anonymous. *Nude Gioconda*.
1513. Black chalk, 13 x 9″.
Musée Condé, Chantilly

The inscrutable smile is, of course, the most famous and tantalizing thing about the face. It is a knowing but equivocal expression, prompting numerous, sometimes farfetched, theories: Does she smile because she is pregnant? Because she recently has lost a child? Because she is really a young man? Because she is asthmatic? Because she has bad teeth? Or, as Sigmund Freud theorized, was Leonardo attracted to her because her smile reminded him of his mother's?

According to Vasari, Leonardo "employed singers and musicians or jesters to keep her full of merriment and so chase away the melancholy that painters usually give to portraits.... As a result, in this painting of Leonardo's there was a smile so pleasing that it seemed divine rather than human; and those who saw it were amazed to find that it was as alive as the original." A nice story, but hardly a satisfying explanation for the sweetly

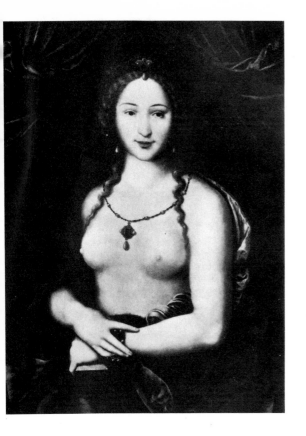

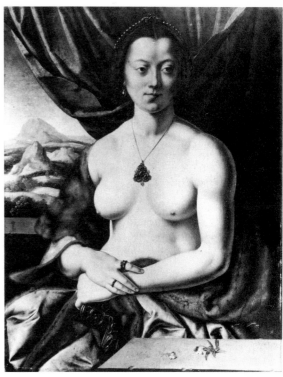

enigmatic smile—which similarly appears in the *Virgin and Child with St. Anne* and *St. John the Baptist*.

 The perennially baffling character of the *Mona Lisa*'s smile was given a new twist by Charles Addams in his famous cartoon that shows a movie audience laughing their collective heads off. Everybody, that is, except the *Mona Lisa*, who sits in the fourth row, incongruously smiling. The cartoon raises a fresh question, according to Leo Steinberg: "Instead of asking why *Mona Lisa* smiles, we wonder what keeps her from laughing."

 The mysterious smile raises numerous questions, as indicated in the popular 1949 song, *Mona Lisa*, by Hollywood songwriters Jay Livingston and Ray Evans:

> "Do you smile to tempt a lover, Mona Lisa,
> Or is this your way to hide a broken heart?
> Many dreams have been brought to your
> doorstep.

above left:
Joos Van Cleve. *Nude Gioconda*. c. 1535. Oil, 37⅜ x 28⅜". Photo Copyright The British Library, London

above right:
Barthel Bruyn. *Nude Gioconda*. 16th century. Oil, 28 x 21¼". Germanisches Nationalmuseum, Nuremberg

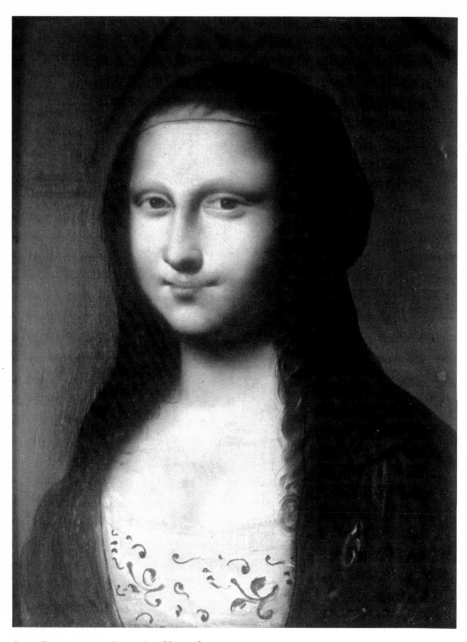

Jean Ducayer (attributed). *Gioconda
with Bodice*. 17th century. Oil, 13¾ x 10¾".
Musée des Beaux-Arts, Tours

Mona Lisa, copy. 17th century.
Oil on canvas, 31½ x 22⅞".
Alte Pinakothek, Munich

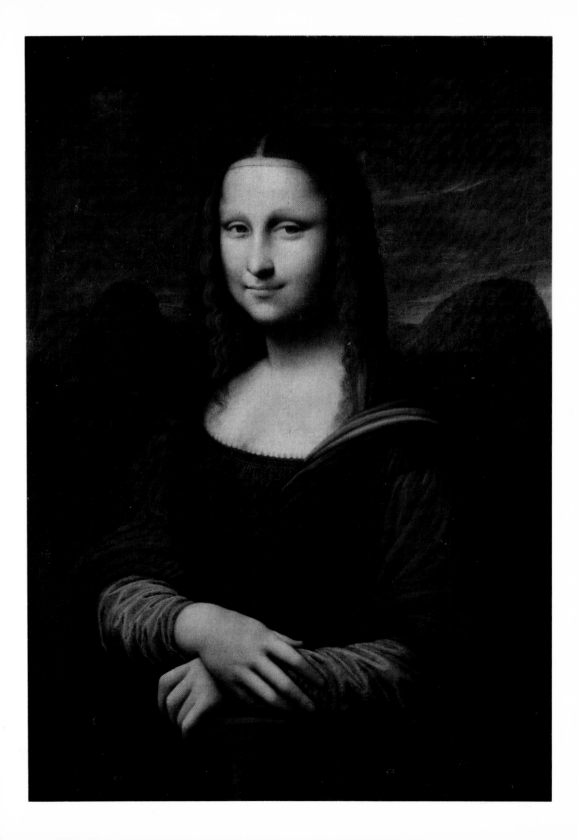

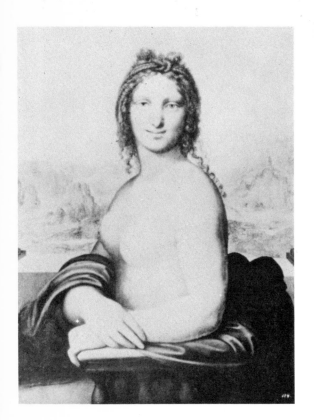

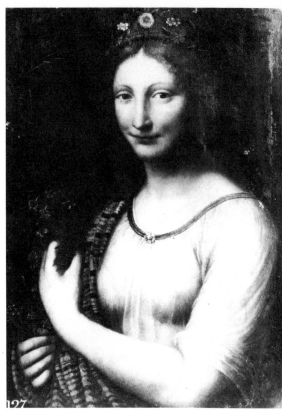

above left:
Salaino. *Portrait of Giovane Donna*.
16th century. Oil, 35 x 26⅜".
The Hermitage, Leningrad

above right:
Bernardino Luini (attributed).
Flora. 16th century. Oil on
canvas, 22¾ x 15". Hampton
Court Palace, London

They just lie there, and they die there.
Are you warm, are you real, Mona Lisa,
Or just a cold and lonely, lovely work of art?"*

But forget about the *Mona Lisa*'s smile for a moment and consider her mysterious eyebrows. What happened to them? In 1625 an Italian scholar, Cassiano dal Pozzo, noted that the lady, "in other respects beautiful, is almost without eyebrows, which the painter has not recorded, as if she did not have them." But according to Vasari, writing at an earlier date, "The eyebrows were completely natural, growing thickly in one place and lightly in another and curving according to the pores of the skin." Was the lady following a fashion of the period for plucked eyebrows or did an over-zealous restorer efface them?

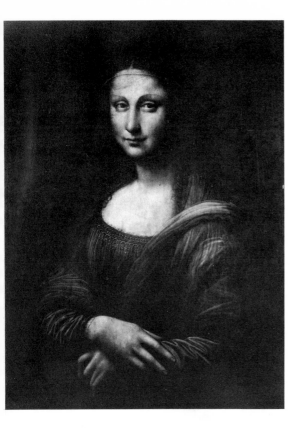

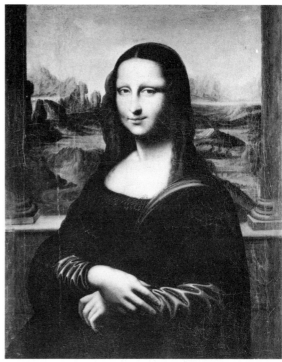

For about 200 years after Leonardo's death, the *Mona Lisa* traveled like a queen among various royal residences, from Fontainebleau and the Louvre to Versailles. Louis XIV, the Sun King, was proud to show her off among his most prized paintings at Versailles. But his successor, Louis XV, banished the *Mona Lisa* to out-of-the-way places, presumably because she had been rendered hopelessly *démodée* by the Rococo style, epitomized by the frothy, cheerfully erotic paintings of Boucher and Fragonard. But *La Gioconda* found an ardent new admirer in Napoleon Bonaparte, who between 1800 and 1804 kept her in his bedroom in the palace at the Tuileries. "Madame Lisa," as he respectfully called her, remained there until she was installed in the Grande Galerie of the Louvre, which had been turned into a public museum after the Revolution.

The *Mona Lisa* and the Louvre were ideally suited to each other. Though she was only one of thousands of

above left:
Anonymous. *Mona Lisa*,
Spanish copy. 16th century.
Oil, 29⅞ x 22½". The Prado,
Madrid

above right:
Anonymous. *Mona Lisa*, copy.
16th century. Oil, 31¼ x 25".
Walters Art Gallery, Baltimore

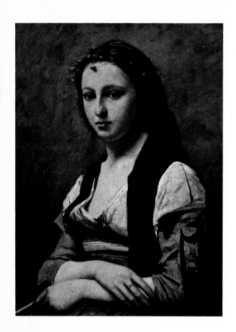

Jean-Baptiste Corot.
Woman with a Pearl. 1868. Oil,
27⅝ x 21⅝". The Louvre, Paris.
(Photograph Musées Nationaux)

opposite:
Terry Pastor. *Magritta Lisa*. 1974.
Watercolor on card, 13 x 9⅞".
Nicholas Treadwell Gallery,
London

artworks on view, many of them recently plundered from neighboring countries by Napoleon, she was considered from the beginning to be one of the greatest treasures ever to enter the place. Her residency at the Louvre marked her debut as a cultural heroine for the general public.

At first, she attracted a passionate following among French artists, including Jean-Baptiste-Camille Corot and Théodore Chassériau, who were among the scores of painters who copied the painting or made variations on it. In addition, the *Mona Lisa* became the darling of the French literati as poets, novelists, and essayists attempted to verbalize her special magic. Curiously, the smile that had appeared "divine" to Vasari's generation began to look sinister in the nineteenth century. The Goncourt brothers in their *Journal* referred to "courtesans of the sixteenth century, one of those instinctive and dissolute creatures who wear like a magic mask the Gioconda smile full of night." The French writer and theater director Arsène Houssaye declared the *Mona Lisa* to be "treacherously and deliciously a woman, with six thousand years of experience, a virgin with an angelic brow who knows more than all the knowing rakes of Boccaccio!"

During the 1850s Théophile Gautier published one of the most quoted interpretations of the *Mona Lisa:* "Is it her beauty?...She is no longer even young... life's finger has left its imprint on the peachlike cheek...but the expression, wise, deep, velvety, full of promise, attracts you irresistibly and intoxicates you, while the sinuous, serpentine mouth, turned up at the corners, in the violet shadows, mocks you with so much gentleness, grace, and superiority, that you feel suddenly intimidated, like a schoolboy before a duchess.... One is moved, troubled, images *already seen* pass before one's eyes, voices whose note seems familiar whisper languorous secrets in one's ears; repressed desires, hopes that drive one to despair stir painfully in the shadow shot with sunbeams; and you discover that your melancholy arises from the fact that *Mona Lisa* three hundred years ago greeted your avowal of love with this same mocking smile which she retains even today on her lips."

The English were latecomers to Giocondophilia, but Walter Pater made up for this tardiness in a famous

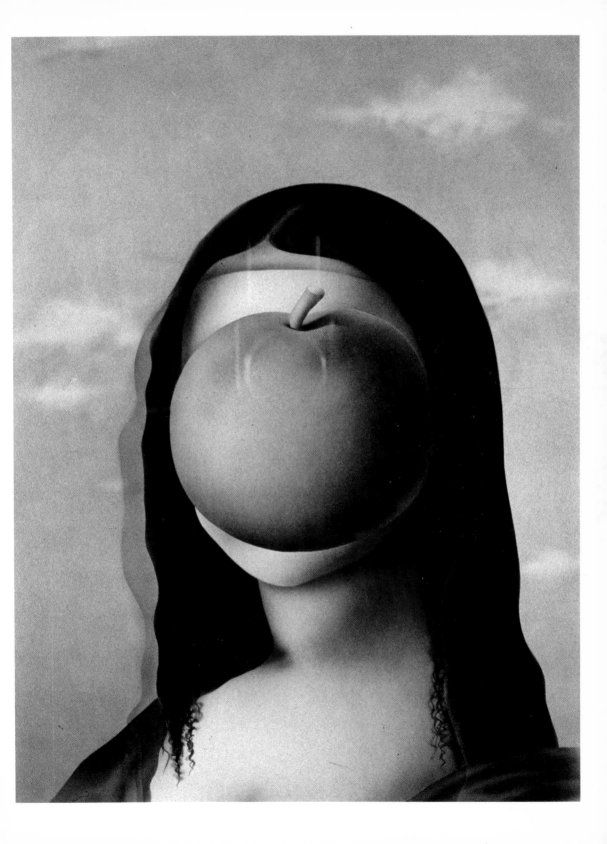

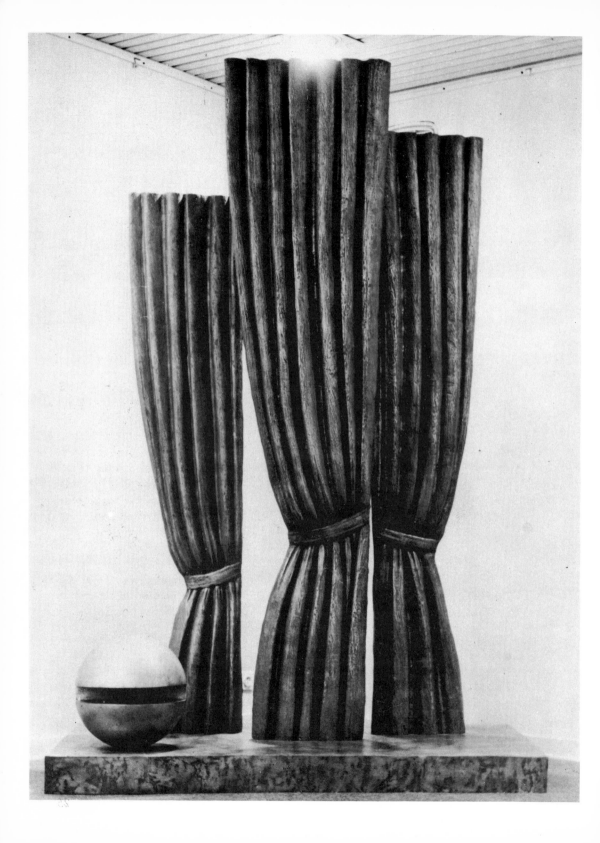

essay, published in 1869, that is astonishingly purple even for an aesthete who prized "hard, gemlike flames." "*La Gioconda* is, in the truest sense, Leonardo's masterpiece.... Hers is the head upon which all 'the ends of the world are come,' and the eyelids are a little weary. It is a beauty wrought out from within upon the flesh, the deposit, little cell by cell, of strange thoughts and fantastic reveries and exquisite passions.... All the thoughts and experience of the world have etched and moulded there, in that which they have of power to refine and make expressive the outward form, the animalism of Greece, the lust of Rome, the mysticism of the middle age with its spiritual ambition and imaginative loves, the return of the Pagan world, the sins of the Borgias. She is older than the rocks among which she sits; like the vampire, she has been dead many times, and learned the secrets of the grave; and has been a diver in deep seas."

By the end of the nineteenth century, the *Mona Lisa* came to signify a particularly perverse *femme fatale*. For some of the Symbolist poets and painters, she existed as a sphinxlike, androgynous, heartless creature, a sister under the skin to Aubrey Beardsley's selfish, domineering women and other *fin-de-siècle* temptresses. The once-seraphic smile appeared even more diabolical to certain twentieth-century writers. E. M. Forster in *A Room with a View* (1903) called it "a Machiavellian smile." Aldous Huxley in his short story "The Gioconda Smile" (*Mortal Coils*, 1922) interpreted it as the deceitful mask of a vengeful woman. Lawrence Durrell in *Justine* (1957) called it "the smile of a woman who has just dined off her husband."

One day in 1911, as if to prove her perfidy, the *Mona Lisa* vanished. A French painter, arriving at the Louvre to make sketches of the picture, discovered it missing from its customary place. When he inquired about the missing painting, he was told that it probably had been taken to the photography department. But no one in that department had seen the *Mona Lisa* that day. Louvre personnel hastily checked the premises and turned up nothing. Almost immediately some sixty policemen appeared. They ushered visitors one at a time to the exits, then methodically searched the place. Finally, the *Mona Lisa*'s antique frame was found in a spiral stairway that led to a courtyard. By late afternoon, the news was out that the *Mona Lisa* had been stolen.

Magritte. *La Joconde*. 1967. Bronze sculpture, 96½ x 65⅜ x 38⅛". Alexandre Iolas, Paris

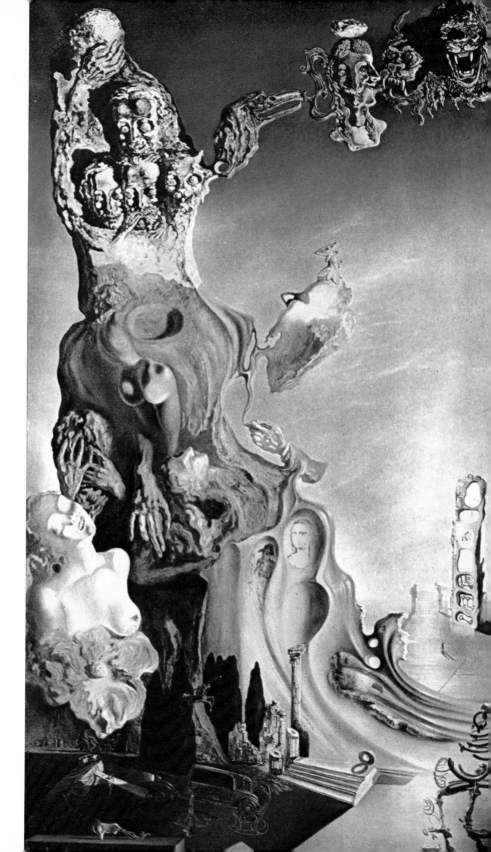

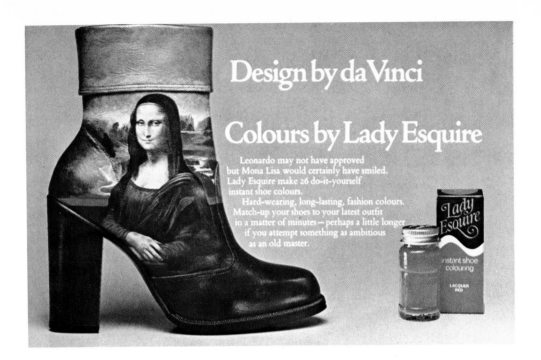

Design by da Vinci

Colours by Lady Esquire

Leonardo may not have approved but Mona Lisa would certainly have smiled. Lady Esquire make 26 do-it-yourself instant shoe colours.

Hard-wearing, long-lasting, fashion colours. Match-up your shoes to your latest outfit in a matter of minutes — perhaps a little longer if you attempt something as ambitious as an old master.

above:
Richard Baldwin. *Mona Lisa boot.* 1978. Lady Esquire Shoe Dye advertisement. Punch Sales Ltd., England

opposite:
Salvador Dali. *Imperial Monument to the Child Woman.* 1929. Oil, 61 x 31⅞". © by ADAGP, Paris, 1980. Private collection

Inimaginable! headlined *Le Matin.* Parisians picked up their newspapers at kiosks and walked away with stunned expressions on their faces, incredulous at and desolated by the news. Rumors began to circulate that the *Mona Lisa* had been swiped by a maniac or, worse, German agents. Artists and writers who figured in the bohemian life of Montmartre were not above suspicion. Pablo Picasso was summoned to a police station for questioning and poet-critic Guillaume Apollinaire was arrested briefly as an alleged accomplice in the theft.

When the Louvre reopened to the public after a week of investigations, Parisians poured in by the thousands to gape at the blank wall where the painting had hung. It is reasonable to assume that at least some of those people had never before set foot in the place. As the weeks and months passed, feelings of suspicion and anger gave way to resignation and humor as cartoonists, songwriters and merchandisers resourcefully satirized and exploited the theft. Farcical postcards depicted the *Mona Lisa* in hypothetical, sometimes risqué situations. One of the highlights of a 1912 parade in Paris was a float

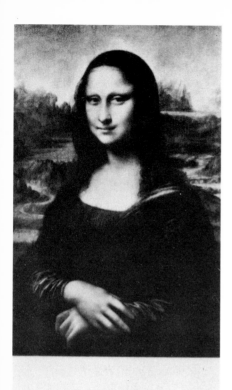

Marcel Duchamp. *L.H.O.O.Q. Rasée*. 1965. Ready-made on reproduction of the *Mona Lisa*, 3⅝ x 2⅝″. Graphics International, Washington, D.C.

featuring a large copy of the *Mona Lisa* sitting in the cockpit of an airplane.

In the autumn of 1913 Alfredo Geri, an antique dealer in Florence, received a letter from a so-called Leonardo Vincenzo who wanted to sell what he said was the *Mona Lisa*. Geri, assuming the painting to be a copy, coolly replied that he dealt only in original works. That December, Vincenzo showed up in Geri's shop, offering to sell the painting for half a million lire. The painting, Vincenzo said, was in his hotel room. They made an appointment to view the painting and Geri notified the police and officials at the Uffizi Museum. The following day Geri and the director of the Uffizi met with Vincenzo, who complacently reached beneath a chest of drawers and removed a small wooden trunk. Opening the trunk, he pulled out a shirt, a pair of shoes, some woolen underwear and, after lifting a false bottom, the *Mona Lisa*. The painting was whisked off to the Uffizi, where it was compared, crack by crack, with photographs of the original and declared to be the missing masterpiece. Ironically, the lost painting came to light only a few blocks from where Leonardo may have initiated the work four centuries earlier.

Leonardo Vincenzo, it turned out, was really Vincenzo Peruggia, an Italian workman in his early thirties who had worked briefly at the Louvre following his emigration to Paris in 1908. In Paris he had a police record for attempted theft and had been imprisoned on one occasion for carrying a weapon. His motive for stealing the *Mona Lisa*, he maintained, was that he wanted to reclaim some of the artworks that Napoleon had looted from Italy; Peruggia naively chose to steal the *Mona Lisa* because she seemed to him "the most beautiful." Without much difficulty, Peruggia had perpetrated the most sensational art theft of the century. For his efforts he received less than a year in jail.

The recovery of the *Mona Lisa* caused jubilation throughout Italy and France and, for that matter, most of the world. Escorted by a retinue of dignitaries, she returned to France in a special compartment on the Milan-Paris express train. On January 4, 1914, she was returned to her place in the Louvre.

The theft of the *Mona Lisa* heightened and intensified her international celebrity. But at the same time that she was becoming a fixture in the public mind, her expanding fame catalyzed a relatively new develop-

ment: Giocondoclasm. Instead of being dreamily admired by romantic artists and poets, La Gioconda was subjected increasingly to ironic, even snide treatment by the new generation of modernists. Leonardo's superb technique, with its distinctive *sfumato* and *contrapposto*, was deemed irrelevant by the Cubists, Fauves, and Futurists. Obviously, a *contrapposto* pose could scarcely survive Cubist treatment, while the Fauves eliminated tonal modeling in favor of pure, uninflected color. In Italy, the Futurists were so impatient with just about everything that reminded them of yesterday, including naturalistic painting, that they urged the burning of museums. Filippo Marinetti, in a fulmination published in 1909 in the Paris *Figaro*, equated museums with cemeteries. "That one should make an annual pilgrimage, just as one goes to the graveyard on All Souls' Day—that I grant. That once a year one should leave a floral tribute beneath the *Gioconda*, I grant you that....[But] admiring an old picture is the same as pouring our sensibility into a funerary urn instead of hurling it far off, in violent spasms of action and creation."

Giocondoclasm had its perfect—if perfectly trivial—culmination at the hands of Marcel Duchamp, who in 1919 took a reproduction of the *Mona Lisa* and drew a mustache and goatee on it. Below the image Duchamp printed "L.H.O.O.Q." Pronounced in French, the letters constitute an obscenity: "elle a chaud au cul"—she has a hot behind. Other modernists, such as Fernand Léger and Kasimir Malevich, produced semiabstract compositions that humorously quote the *Mona Lisa*'s image. In any case, the *Mona Lisa*'s numerous detractors over the years never succeeded in discrediting the marvelous artistry of the work or diminishing its enormous popularity. To the contrary, the Giocondoclasts have only contributed to the further mythicizing of the *Mona Lisa*.

By the mid-twentieth century the *Mona Lisa* had infiltrated so many levels of culture and had been reproduced to such a stupefying extent that she commanded the attention of Pop artists. Robert Rauschenberg, Marisol, and Tom Wesselmann were among the many artists who in the late 1950s and early 1960s took note of the *Mona Lisa*'s ubiquitous presence in the social landscape. Andy Warhol, in his silkscreened painting of thirty *Mona Lisas*, regimented in five rows of six each,

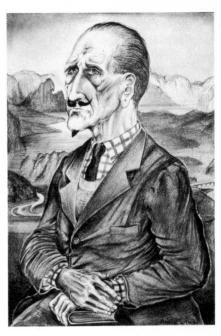

Bruno Caruso. *L.H.O.O.Q. A Marcel Duchamp*. 1977. Pencil. Published in *Mitologia dell'Arte Moderna*, Franco May Edizioni S.r.L., Rome

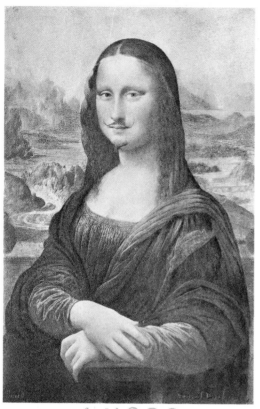

L.H.O.O.Q.

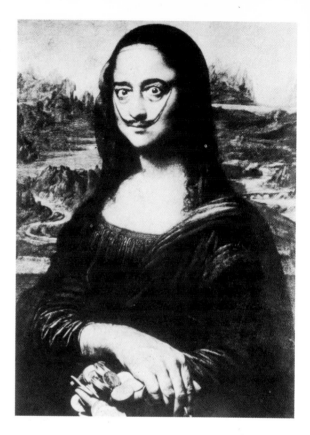

offers a brilliantly sardonic commentary on how modern society transforms a unique icon into a shoddily duplicated cliché.

The *Mona Lisa* embarked on a new career as ambassadress in 1963, when the French government sent her to the United States. She sailed on the S.S. *France* and attracted record crowds, first at the National Gallery of Art in Washington, D.C., then at the Metropolitan Museum of Art in New York. Since she was in the official custody of President John F. Kennedy, she was protected at all times by a special detail of the Secret Service. The *Mona Lisa*'s next diplomatic missions occurred in 1974 when she was sent to the Pushkin Museum in Moscow and the Museum of Western Art in Tokyo. While in Japan, the *Mona Lisa* finally was provided with the only thing certain people felt she lacked—a voice. Japanese scientists figured out a way to measure her facial features and cranial bone structure,

above left:
Marcel Duchamp. *L.H.O.O.Q.* 1919. Ready-made with pencil on reproduction of the *Mona Lisa*, 7¾ x 4⅞". Tarica Ltd., Paris

above right:
Philippe Halsman. *Dali as Mona Lisa*. 1954. Photomontage. Private collection

opposite:
Andy Warhol. *Mona Lisa*. 1963. Silkscreen, 44⅛ x 29⅛". © Andy Warhol. Collection Eleanor Ward, New York

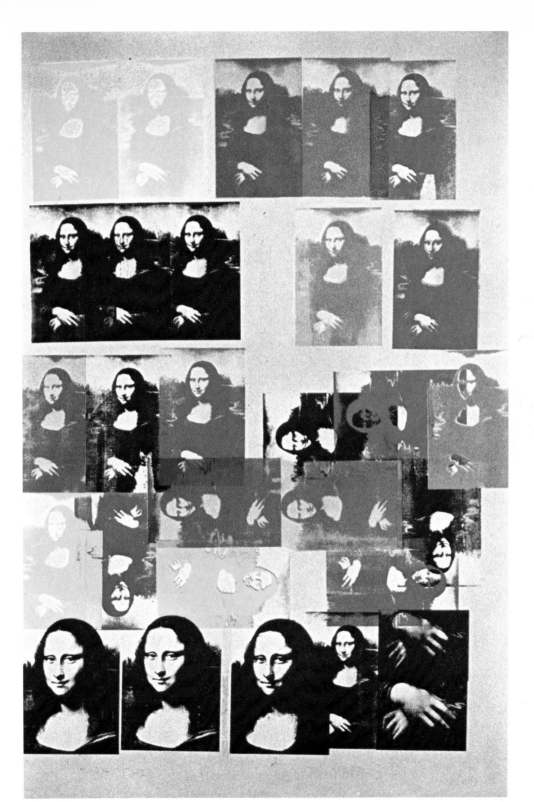

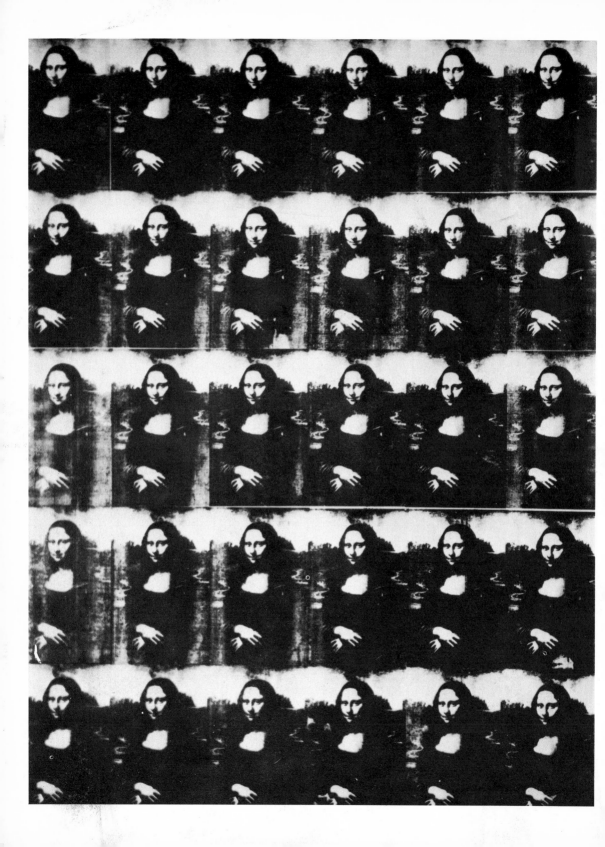

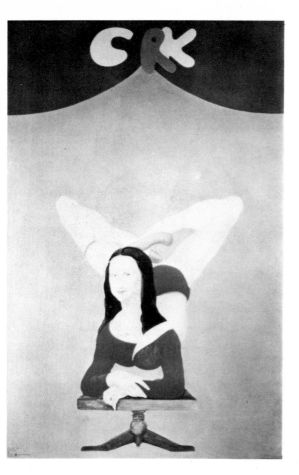

left:
Maciej Urbaniec. *Circus*. 1970.
Polish poster, 38⅛ x 26″.
Preussischer Kulturbesitz,
Kunstbibliothek Berlin der
Staatlichen Museum. W.A.G.,
Warsaw

below:
Paul Wunderlich. *In Tears*. 1972.
Color lithograph, 25⅝ x 19⅝″.
Brusberg Gallery, Hannover

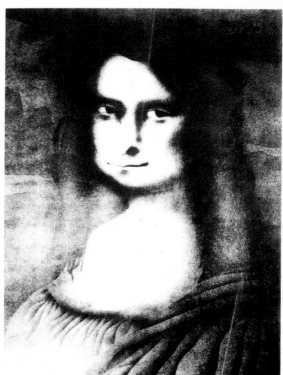

opposite:
Andy Warhol. *30 Are Better Than One*.
1963. Silkscreen on canvas, 110 x 82½″.
© Andy Warhol. Collection Peter
Brandt, Greenwich, Conn.

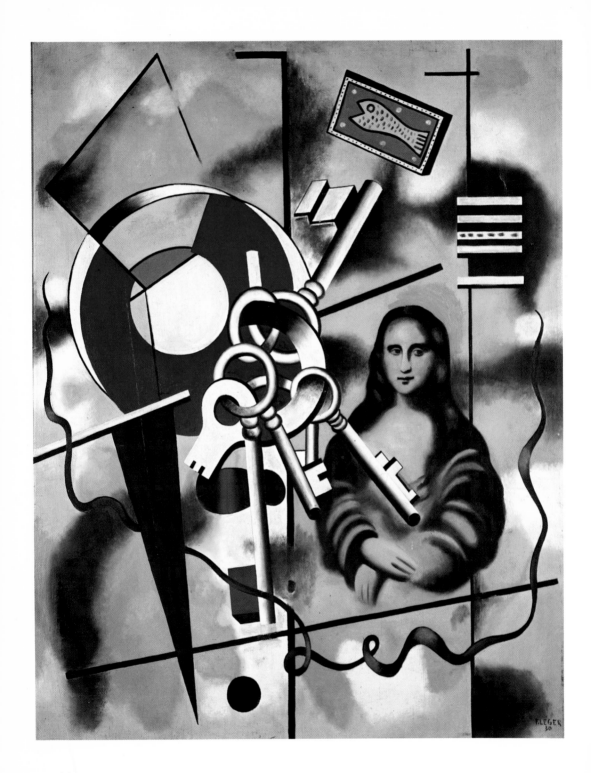

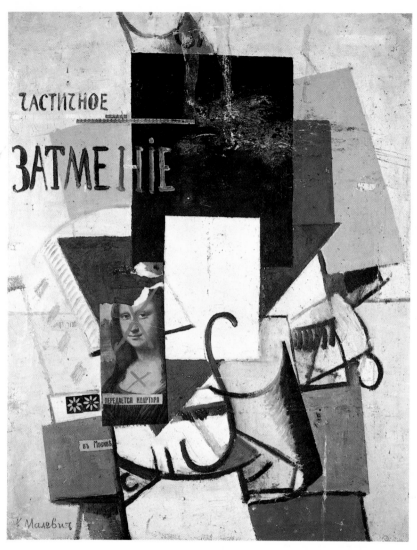

Kasimir Malevich. *Composition with Mona Lisa*. 1914. Oil on canvas and collage, 24⅜ x 19¼″. Wilhelm-Lehmbruck Museum, Duisburg

Fernand Léger. *Gioconda With Keys*. 1930. Oil, 35⅞ x 28¾″. (Representative: SPADEM) Musée Fernand Léger, Biot

Tom Wesselmann. *Great American Nude #35*. 1962. Mixed media construction, 48 x 60″. Private collection

Robert Rauschenberg. *Mona Lisa*.
1958. Combined transfer drawing,
22¾ x 28¾". Private collection

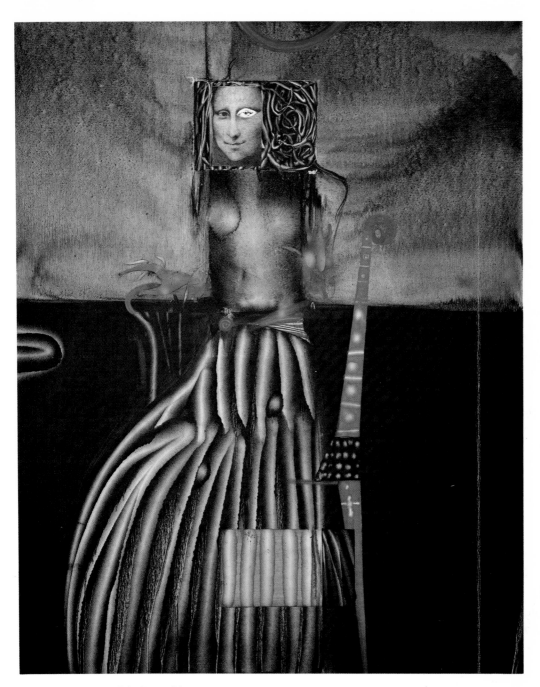

Paul Wunderlich. *Die Grüne Lisa*.
1964. Oil, 63¾ x 51⅛".
Wilhelm-Lehmbruck Museum,
Duisburg. (Photograph Brusberg
Gallery, Hannover)

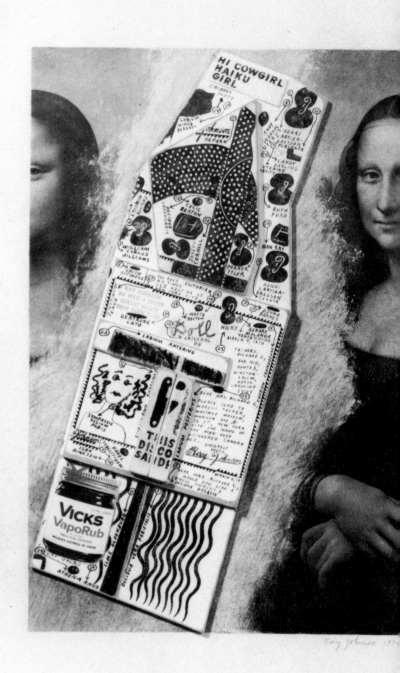

Ray Johnson.
Cervix Dollar Bill. 1970.
Collage, 19¾ x 28⅜".
Richard Feigen Gallery,
New York & Chicago.
(Photograph Eric
Pollitzer)

40

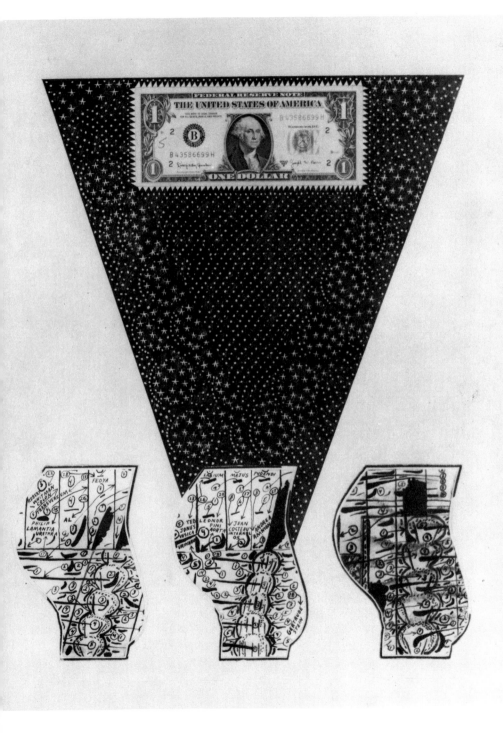

41

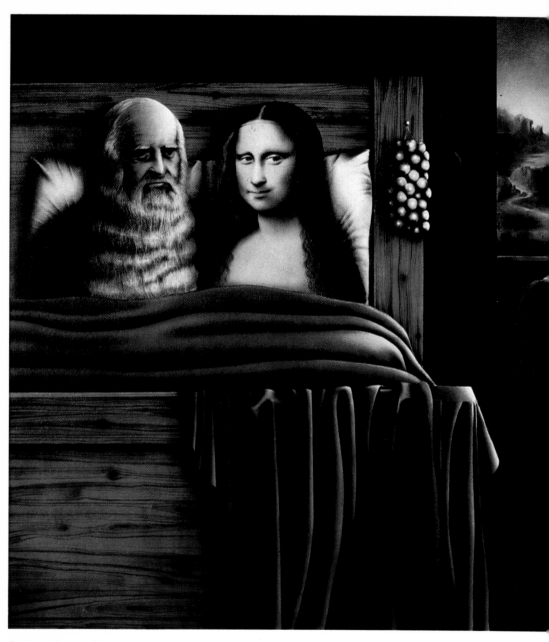

Graham Dean. *Mona and Leo*. 1974.
Acrylic on canvas, 28⅜ x 33".
Nicholas Treadwell Gallery, London

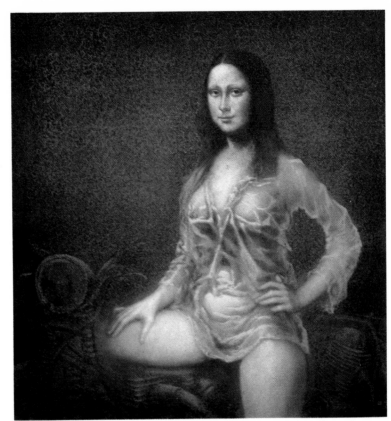

Ludmil Siskov. *Moto Lisa*. 1973.
Acrylic on canvas, 35⅜ x 33⅞".
Nicholas Treadwell Gallery, London

then correlated the measurements with allegedly corresponding voice tones. The result? A tape recording on which a soft, deep voice says in flawless Italian: "I am Elisabeth. I am called Mona Lisa. I was born in Florence, I married Giocondo, and I was twenty-six years old when Leonardo da Vinci painted me while I was in hiding. I am glad that Japanese can hear me."

Whether mute or vocal, the *Mona Lisa* continues to inspire more verbiage than any other work of art. Among recent books devoted to her, the best is Roy McMullen's *Mona Lisa: The Picture and the Myth* (1975), a carefully researched, entertainingly written account of the painting's complex history. Perhaps the silliest book is Pierre La Mure's 1976 novel, *The Private Life of Mona Lisa*. La Mure, who wrote about Toulouse-Lautrec in *Moulin*

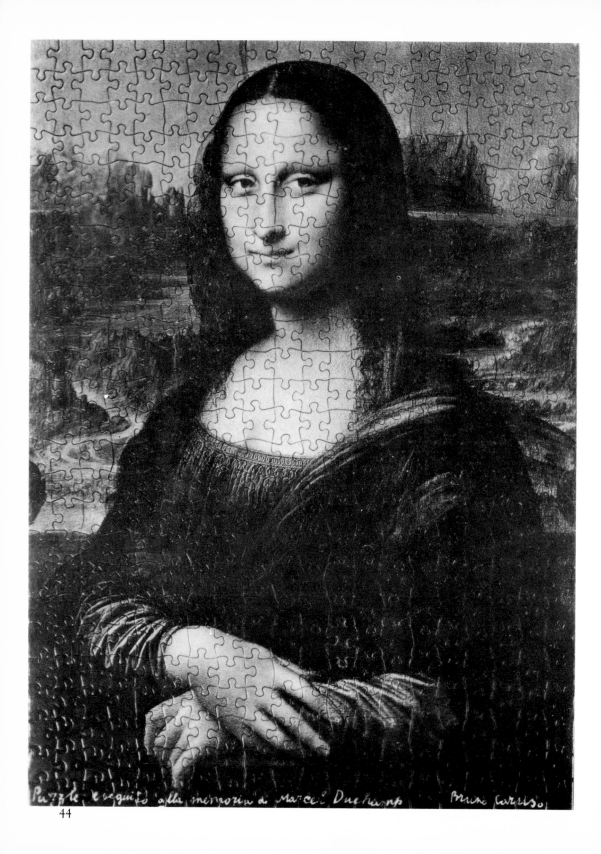

Puzzle eseguito alla memoria di Marcel Duchamp Bruno Caruso

44

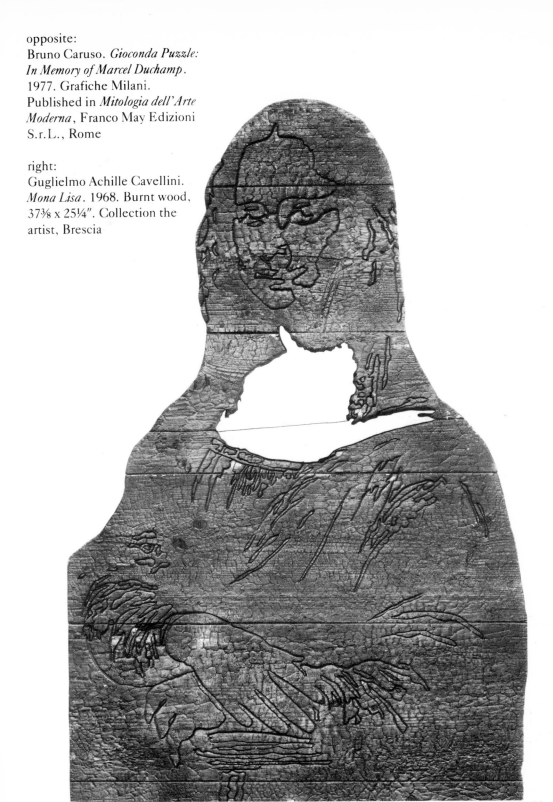

opposite:
Bruno Caruso. *Gioconda Puzzle: In Memory of Marcel Duchamp*. 1977. Grafiche Milani. Published in *Mitologia dell'Arte Moderna*, Franco May Edizioni S.r.L., Rome

right:
Guglielmo Achille Cavellini. *Mona Lisa*. 1968. Burnt wood, 37⅜ x 25¼". Collection the artist, Brescia

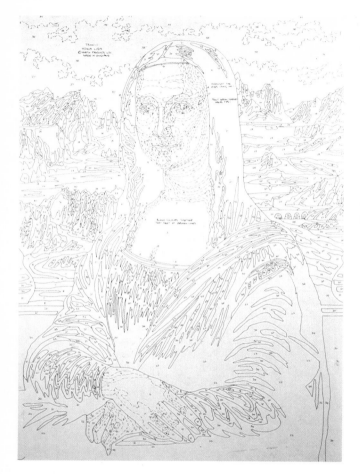

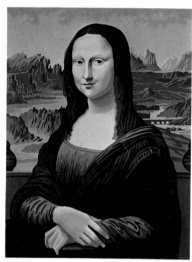

left, line version:
above, finished version:
Mona Lisa Airfix Painting by Numbers.
1968. 36 x 28". Airfix Products
Limited, London

Rouge, sets out to debunk Leonardo, who is portrayed as a foppish nitwit with a perfumed beard and waxed mustache. When Francesco del Giocondo first mentions the proposed portrait to his wife, she petulantly protests that she is much too busy to sit for a portrait. "And on top of all this," she complains, "I have to start organizing our garden party in June." Later, she relents. Leonardo, "an elderly dandy in a maroon velvet doublet," poses her in the garden, an act that "required much frowning, squinting, stepping back and forth, and twirling of his mustache." Lisa becomes increasingly annoyed by the various interruptions that prevent Leonardo from finishing the portrait. "The truth is that you don't like painting!" she pouts. "Geometry, anatomy, mathematics— anything is a good excuse for you to avoid painting." She

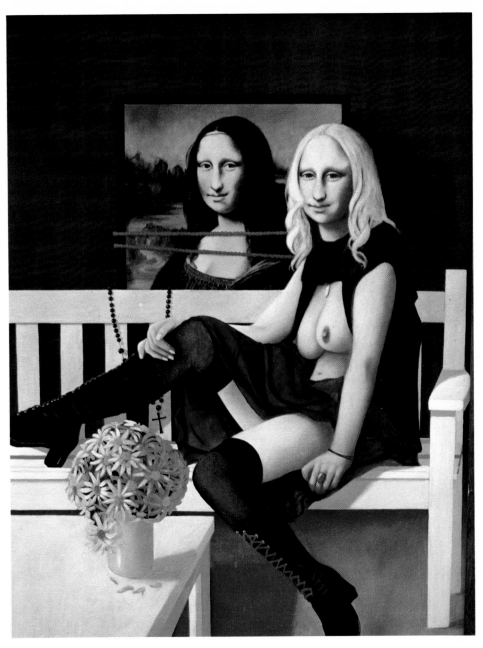

Chester Browton. *A Chip Off the Old Block*. 1974.
Oil on canvas, 35⅞ x 28″.
Nicholas Treadwell Gallery, London

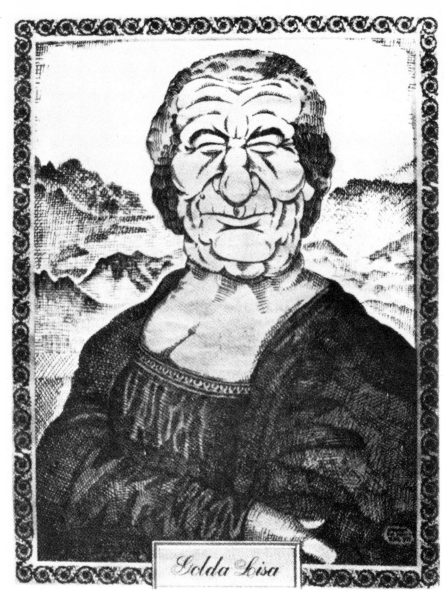

David Geva. *Golda Lisa*. 1973.
Photomontage, 25⅝ x 18⅝″.
Printer: Shoha

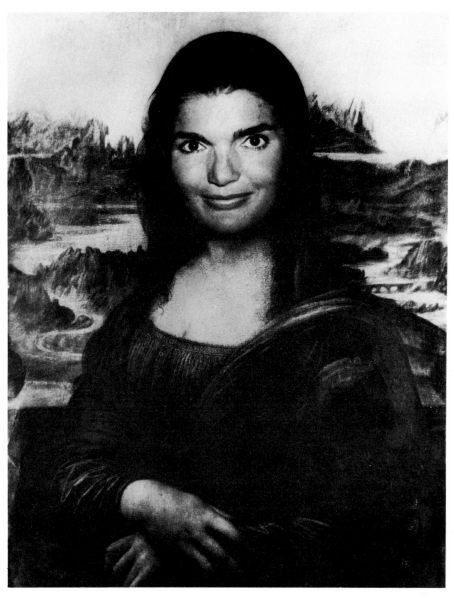

Alfred Gescheidt.
Jackie Kennedy Onassis as Mona Lisa. 1977.
Photomontage. (Photograph © 1977
by Alfred Gescheidt, New York)

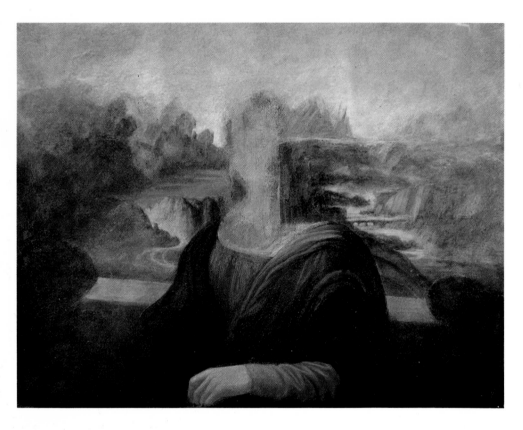

Anonymous. *Headless Mona Lisa*. 1977.
Oil, 20 x 15″. Private collection, London

Rick Meyerowitz. *Mona Gorilla*. 1971.
Poster, 33 x 16½″.
Bahm Bros., Inc., New York

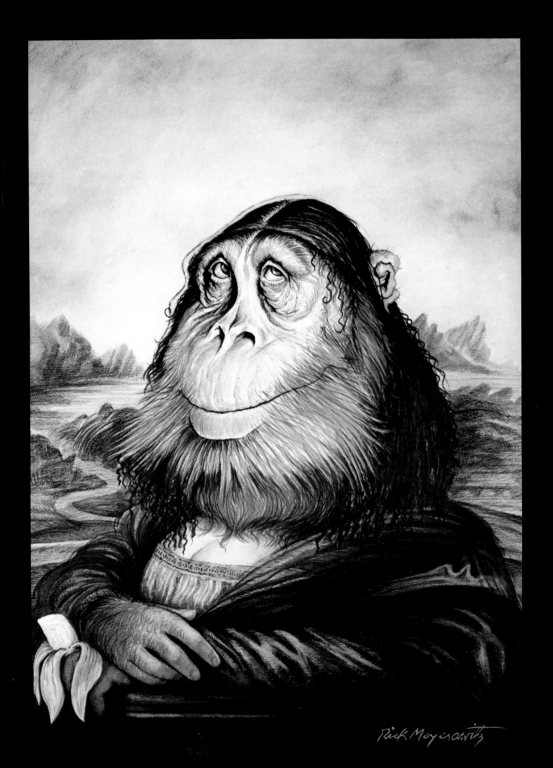

Rick Meyerowitz

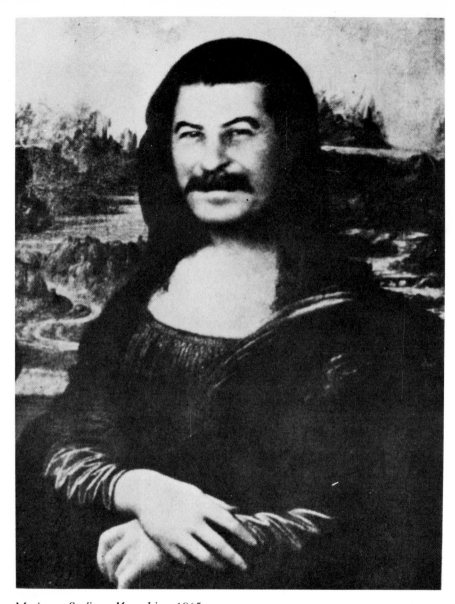

Marinus. *Stalin as Mona Lisa*. 1965.
Photomontage. Wilhelm-Lehmbruck Museum, Duisburg

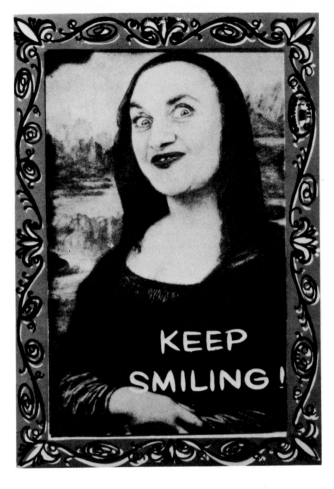

Keep Smiling. Post Card, 6 x 4″.
Collection Steve Winters

criticizes his flashy clothing, spitefully adding: "And stop using perfume."

In one way or another the *Mona Lisa* bewitches more people today than at any time in the past. Of course, we see the *Mona Lisa* differently than previous generations did, because we cannot look at the picture without taking into account her ever-growing reputation. Our view of her has been affected by all the copies, caricatures, homages, and legends that have accrued over nearly five centuries. The multitude of *Mona Lisa* artifacts and commentaries creates an ever-shifting, ever-expanding context for Leonardo's lady, compounding her inherent ambiguity. It is reasonable to assume that future generations will continue to find her ever more fascinating.

Jasper Johns. *Color Numerals: Figure 7*. 1969.
Color lithograph, 38 x 38".
Gemini G.E.L., Los Angeles.
(Courtesy Castelli Graphics, New York)

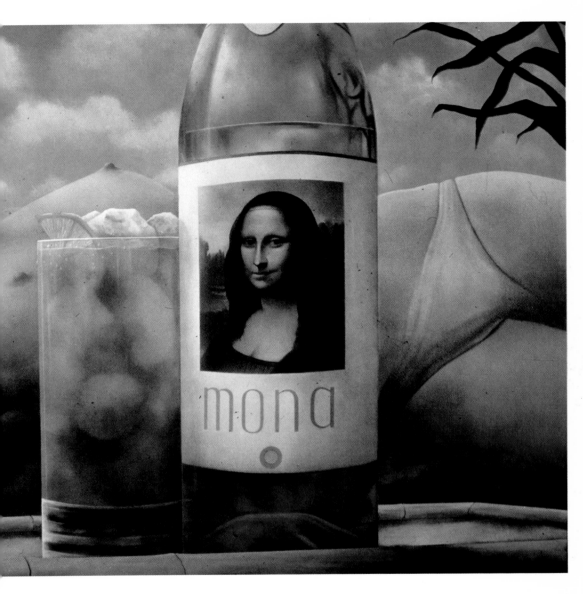

Mike Mycock. *Just Another Product*. 1974.
Acrylic on canvas, 35⅞ x 48″.
Nicholas Treadwell Gallery, London

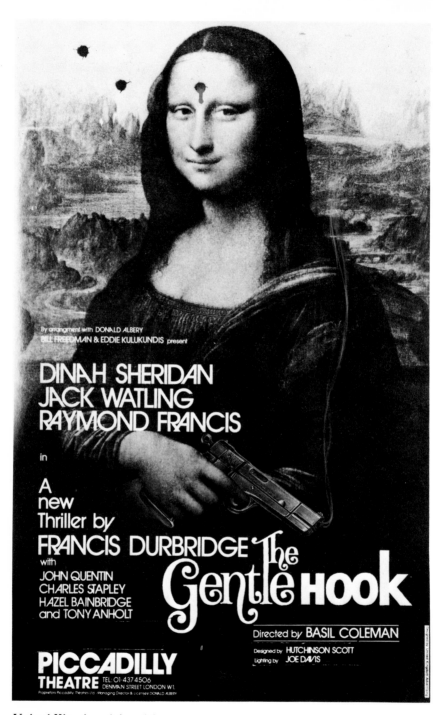

United Kingdom Advertising.
The Gentle Hook. 1971. Theater poster.
Producers: Bill Freedman and Eddie Kulukundis, London

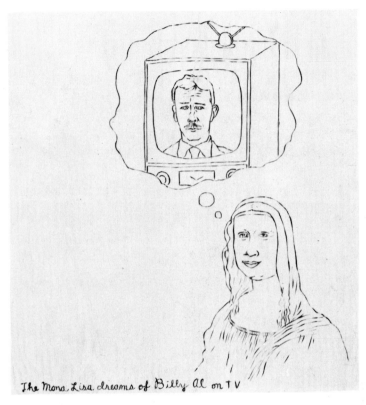

Phil Garner.
The Mona Lisa Dreams of Billy Al on TV
(refers to Billy Al Bengston). 1979.
Woodburning onto plywood, 20 x 20″.
Private collection

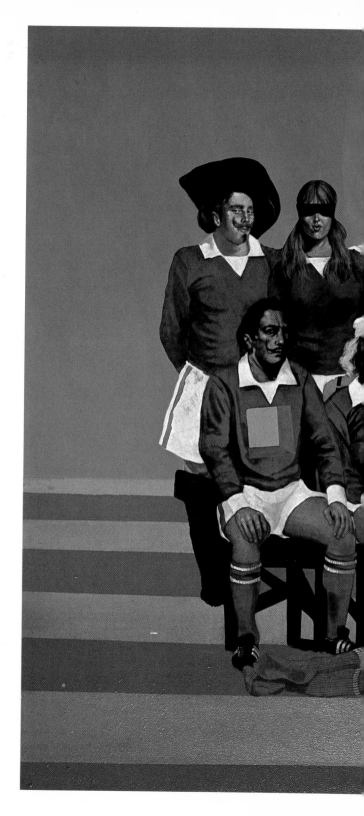

Mike Francis. *The Team*. 1976.
Acrylic on board, 28⅜ x 35⅞".
Nicholas Treadwell Gallery,
London

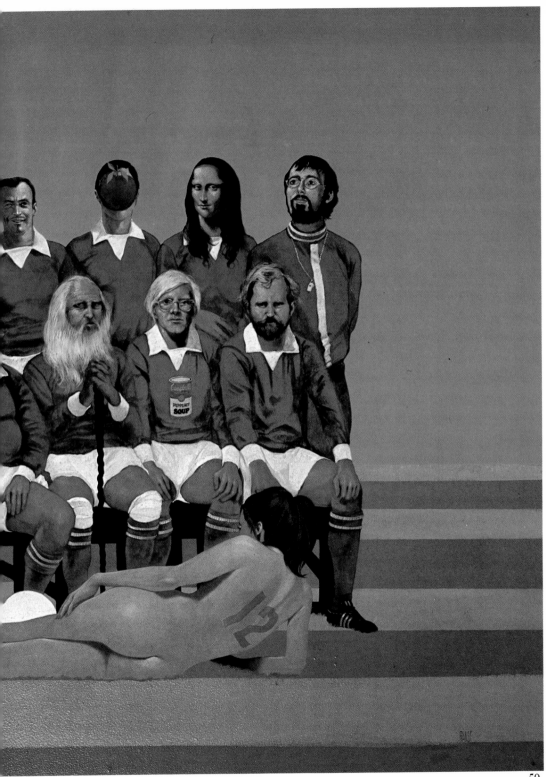

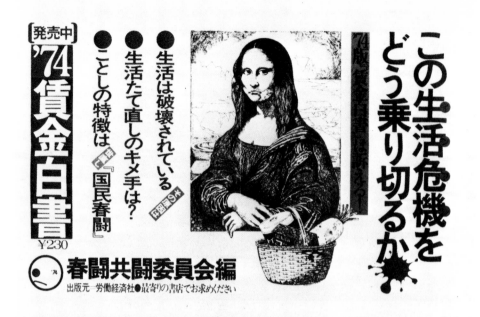

Japanese Trades Union Poster. 1974. Fuji Xerox, Tokyo

Takashi Yonemura. *Japanese advertisement for art book*. 1967.
Bijutsu Shuppan Design Center, Tokyo

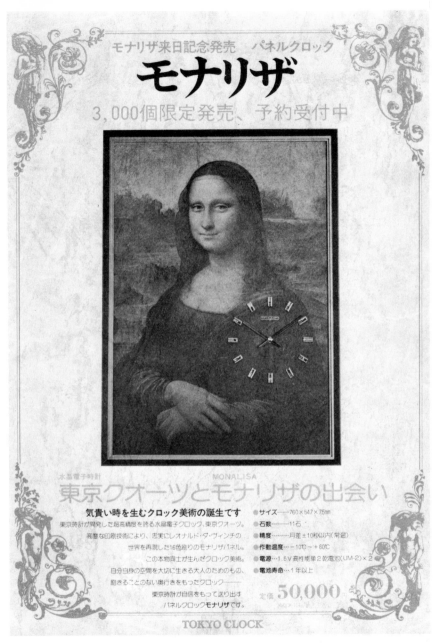

Tokyo Clock. 1977. Distributed by K. Griffiths, Bristol

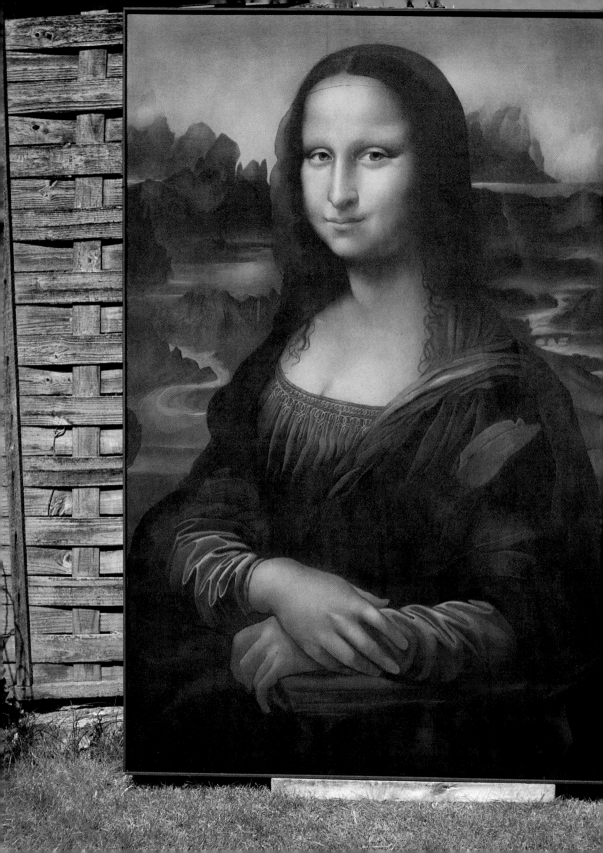

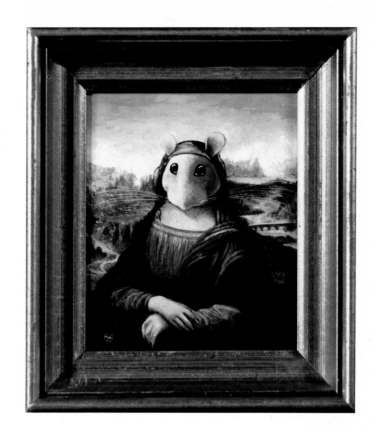

Rita Greer. *Mona Lisamouse*. 1977.
Oil on hardboard, 3⅛ x 2½".
Collection the artist

Mike Gorman. *Big Mona*. 1974.
Acrylic on canvas, 72 x 48".
Nicholas Treadwell Gallery, London

63

Joyce Macdonald.
Mona Lisa wth Make-Up. 1978.
Copyright *Sunday Times*, London

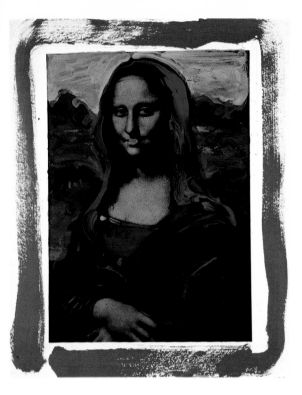

left:
Peter Max. *Mona Lisa III*. 1975.
Acrylic overpaint on lithograph,
20¹/₃ x 16¼". Collection the artist

Clive Barker. *Bandaged Mona Lisa*. 1970.
Collage, 8 x 10".
Collection Mr. and Mrs. M. Chow.
(Photograph Prudence Cummings Ass., Ltd.,
London)

above and right:
Don Martin. *Mona Lisa*. 1974.
Illustrations, *MAD* Magazine.
© 1974 by E. C. Publications, Inc.

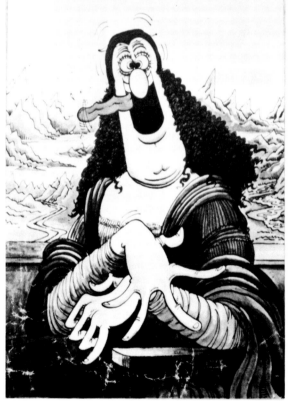

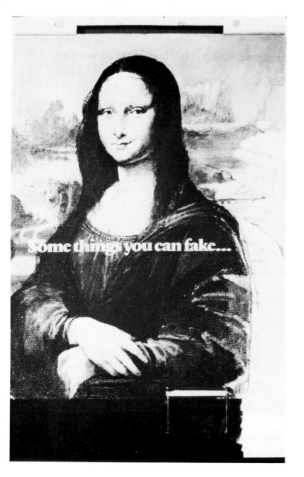

Mona Lisa. 1977.
Doncella Cigar advertisement.
Produced by Sharps Advertising Ltd., London

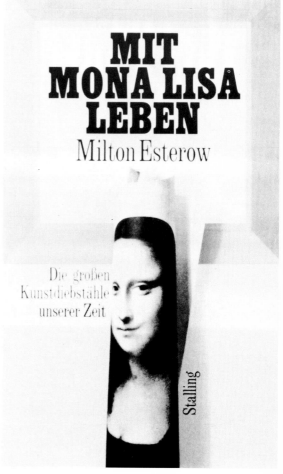

Jan Bucholz. *Mona Lisa*. 1968.
Book cover. Stalling Verlag,
Hamburg

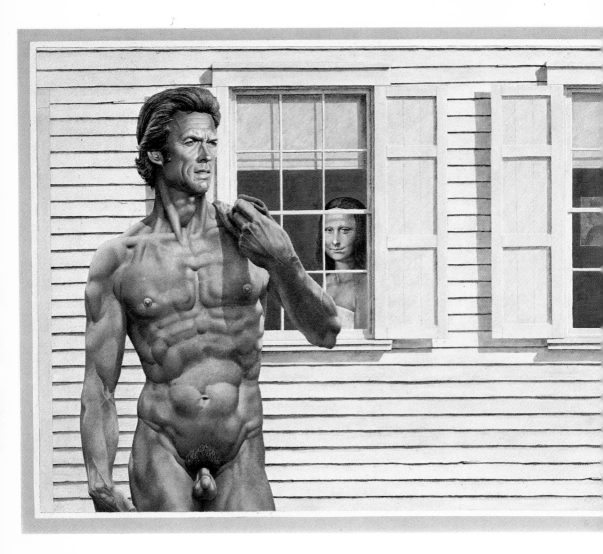

Chris Brown. *Mio Nome E Pecos*. 1978.
Oil on canvas, 24 x 59⅞".
Nicholas Treadwell Gallery, London

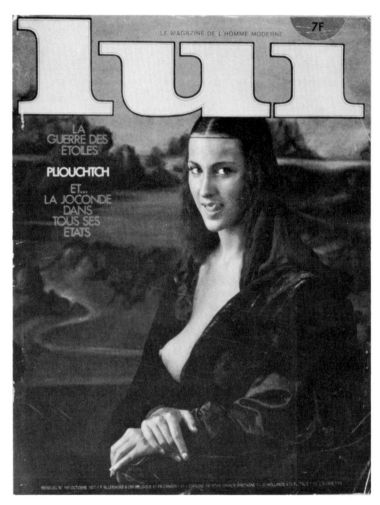

Paulo Calia. *Mona Lisa*. 1977.
Cover, *Lui* Magazine, Paris

Shusaku Arakawa. *Mona Lisa*. 1971.
Silkscreen, 44½ x 33½".
Multiples, Inc., New York.
© by Foto Bernd Kirtz BFF, Duisburg

Bill Birch. *Mona Lisa*. 1977.
Ikon oil painting, 15 x 12".
Collection Steve Winters

David Dragon. *Mona Lisa*. 1978.
Record cover.
EMI Records, Ltd., London

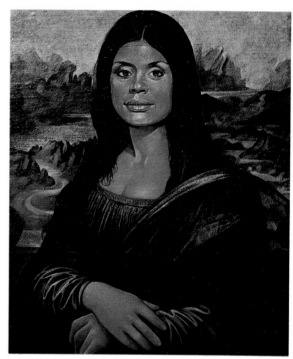

Design Group, Newcastle. *Mona Lisa*. 1978.
Wool advertisement.
Patons & Baldwins, Ltd.

Mona Lisa. 1976.
Mock magazine cover.
Collection Steve Winters

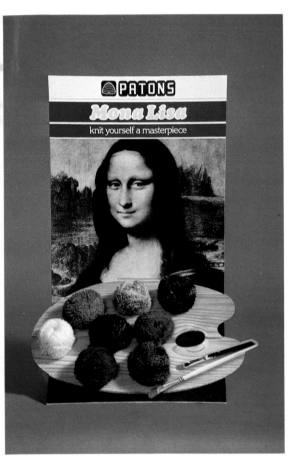

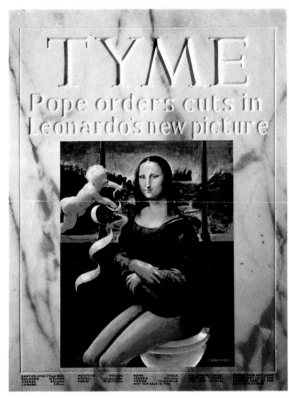

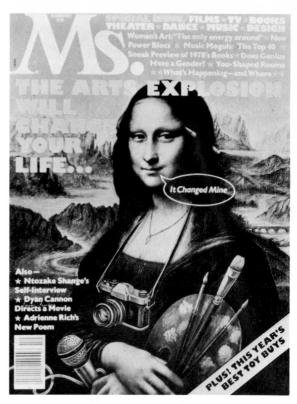

Jean Lagarrigue. *Mona Lisa*. 1973.
Cover, *Graphis 164*. GRAPHIS,
International Journal of Graphic
Art and Applied Art,
The Graphis Press, Zurich

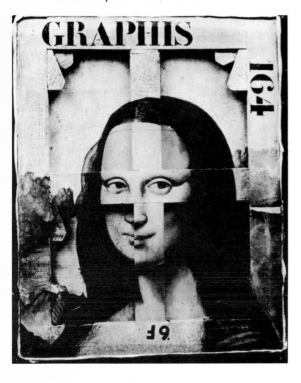

Teresa Fasolino. *Mona Lisa*.
December, 1977. Cover,
Ms Magazine, New York

opposite:
Donald Punchatz. *Mona Lisa*. 1969.
Book illustration.
Smith, Kline & French, Philadelphia

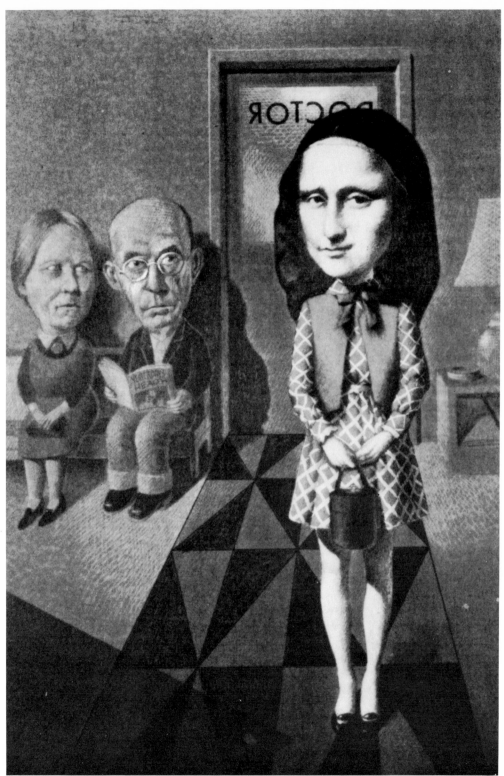

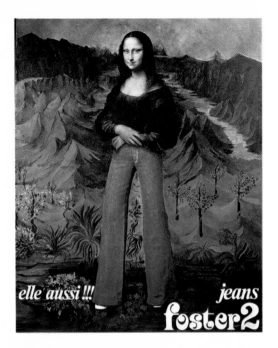

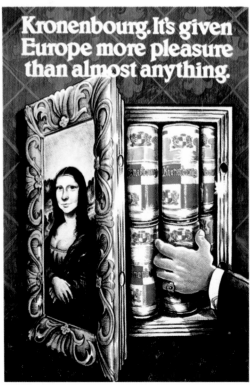

above left:
Mona Lisa. 1978.
Foster 2 Jeans advertisement, Paris

below left:
Rick Meyerowitz/Martyn Walsh/Andrew
Rutherford. *Mona Lisa*. 1978.
Kronenbourg Beer advertisement.
Harp Sales Ltd. Saatchi & Saatchi
Garland-Compton Ltd., London

below and opposite:
Makoto Nakamura. *Mona Lisa*. 1971.
Printing process. Ichiban-kan Gallery,
Tokyo

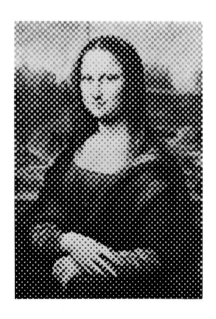

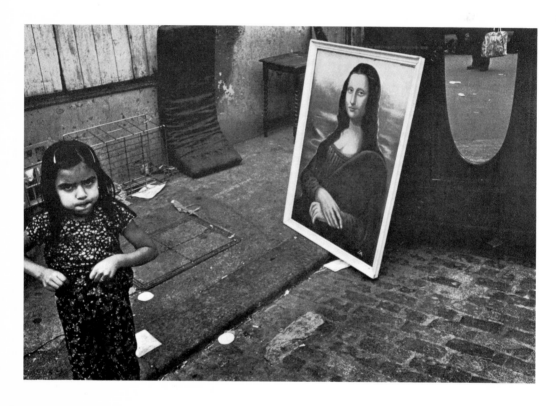

Paul Trevor. *Cheshire Street: Sunday Around Brick Lane*.
© 1978 Paul Trevor. Post Card, 4¾ x 7".
Shenval Press, England

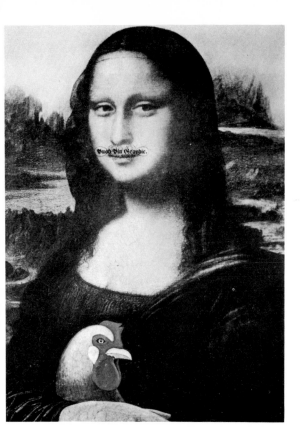

Seymour Chwast. *Mona Lisa with Mustache and Rooster*. Push Pin Studios 20th Anniversary Poster, New York

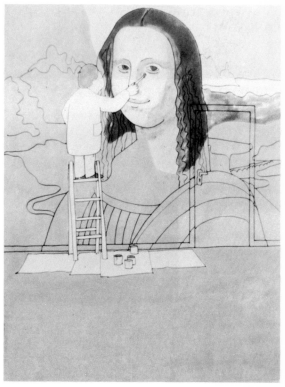

Steve Winters. *Mona Lisa*. 1978. Cartoon, 15 x 12″. Collection Steve Winters

Bill Dare. *Mona Lisa*. 1978.
Beauty feature,
MS, London

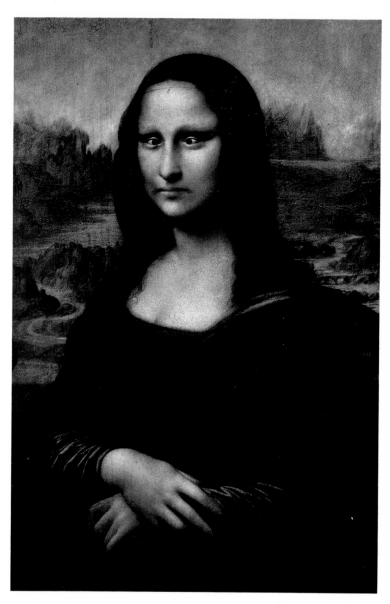

Cross-eyed Mona Lisa. 1979.
JVC, VHS commercial.
Produced by Harrison McCann

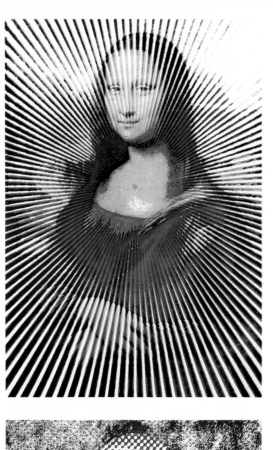

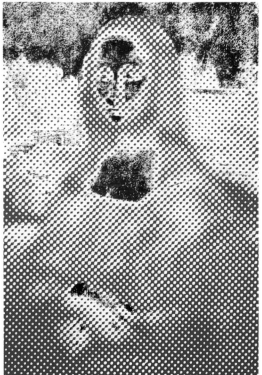
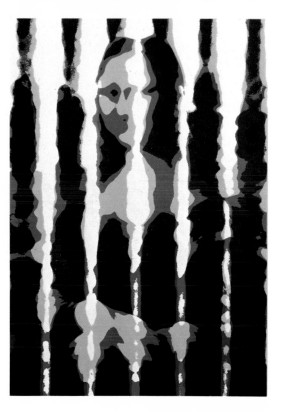

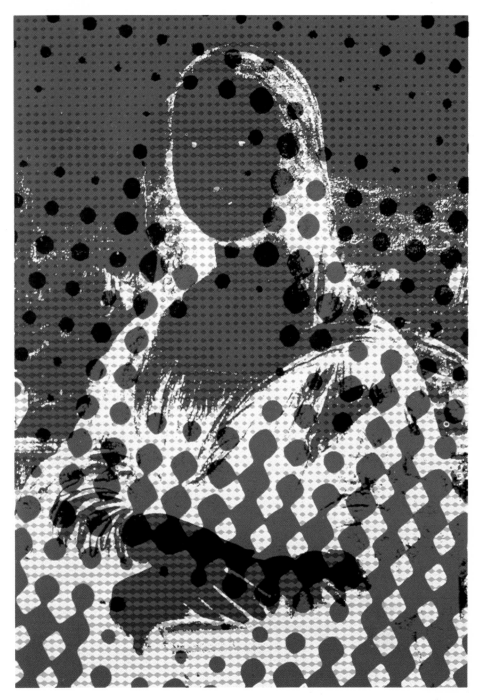

opposite and above:
Shigeo Fukuda. *Mona Lisa*. 1971. Printing process. Ichiban-kan Gallery, Tokyo

Makoto Nakamura. *Mona Lisa*. 1971.
Printing process. Ichiban-kan Gallery, Tokyo

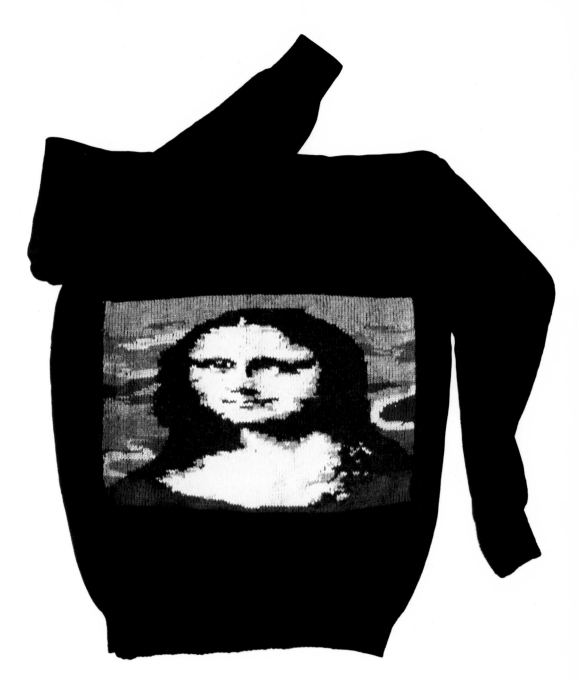

Mona Lisa knitted on sweater.
Mrs. E. Storey. Collection the author

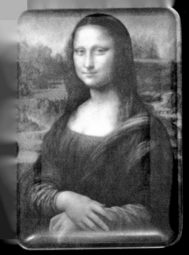

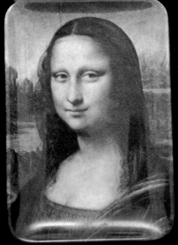

opposite above:
Mona Lisa. Plate. Collection Steve Winters

opposite below:
Mona Lisa. Plate. Collection Steve Winters

above:
Mona Lisa. Ashtrays. Collection Steve Winters

right:
Mona Lisa. Candle. Collection Steve Winters

ALL PURE LINEN Mona Lisa MADE IN IRELAND

Mona Lisa. Jewelry.
Collection Steve Winters

opposite:
Mona Lisa. Drying-up Cloth.
Collection Steve Winters

Mona Lisa.
Padded Satin Cigarette Box.
Collection Steve Winters

Mona Lisa. Pentels Crayon Box.
Collection Steve Winters

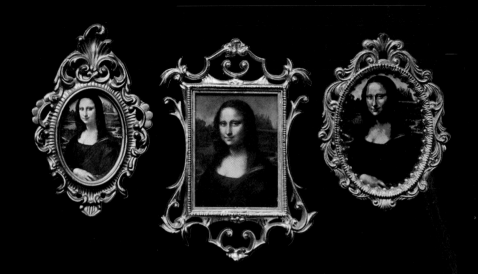

Mona Lisa. Plastic Miniatures.
Collection Steve Winters

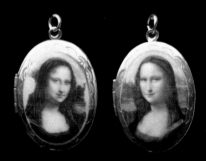

Mona Lisa. Lockets.
Collection Steve Winters

Mona Lisa. Badge.
Collection Steve Winters

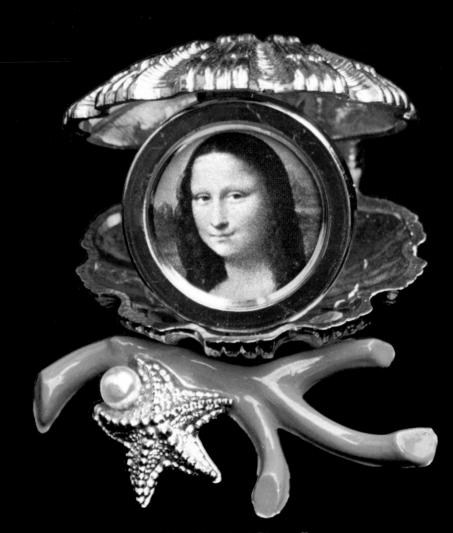

Mona Lisa. Shell Picture Frame.
Collection Steve Winters

Mona Lisa. German and Saudi Arabia Stamps. Collection Steve Winters

Mona Lisa. Deodorant Block Holder.
Collection the author

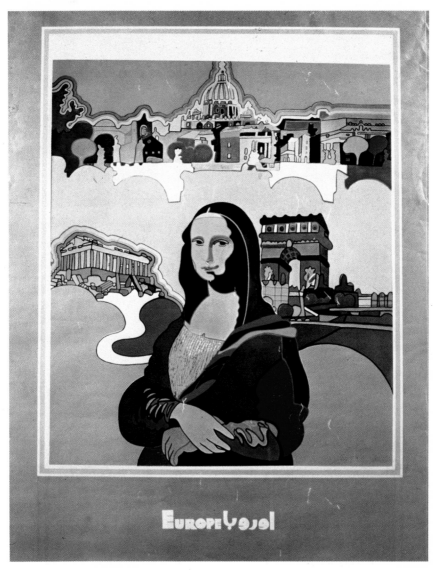

Jafar Islah. *Mona Lisa*. 1977.
Kuwait Airways Calendar, 12 x 10″.
Jafar Islah, Kuwait

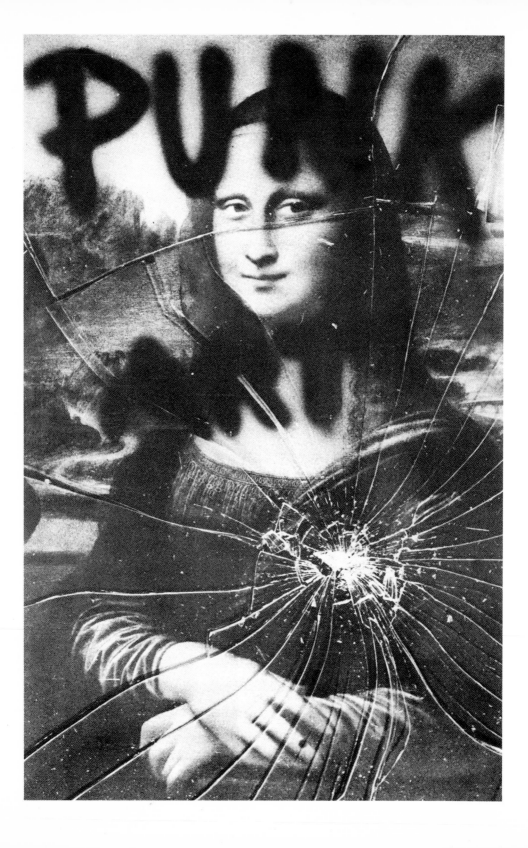

opposite:
Miller, Ringma, & Hoppe. *Mona Lisa Smashed*. 1978.
Cover, *Punk*. 12 x 7¾". Copyright© April 23, 1978 Miller
& Ringma and Washington Project for the Arts.

INDEX OF ARTISTS AND OBJECTS

Acknowledgments

Mary Rose Storey would like to acknowledge her appreciation for all their assistance to the Brusberg Gallery, Hannover; the Leo Castelli Gallery, New York; the Nicholas Treadwell Gallery, London; the Whitney Museum of American Art, New York; the Wilhelm-Lehmbruck Museum, Duisburg; the Sidney Janis Gallery, New York; and for photography her special thanks to Andrew Greaves, Richard Murby, and Michael Parry.

Robert Arneson.
George and Mona in the Baths of Coloma. 1976.
Glazed ceramic, 30 x 57 x 25″. Stedelijk Museum, Amsterdam

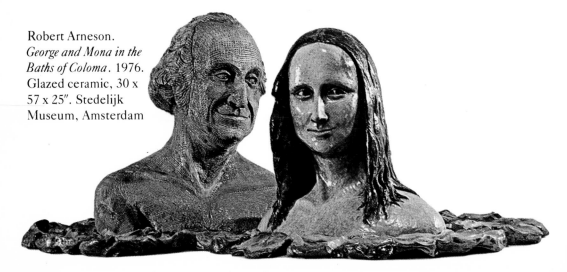